AVIATION

BRITAIN IN PICTURES

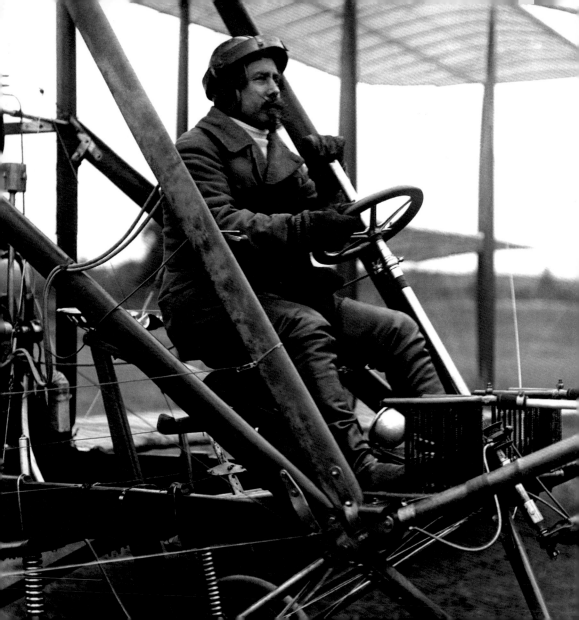

AVIATION

BRITAIN IN PICTURES

AMMONITE
PRESS

**PRESS
ASSOCIATION**
Images

First published 2012 by
Ammonite Press
an imprint of AE Publications Ltd,
166 High Street, Lewes, East Sussex, BN7 1XU

This title has been created using material first published in
100 Years of Aviation (2010)

ISBN 978-1-90770-848-0

British Cataloguing in Publication Data. A catalogue
record of this book is available from the British Library.

Editor: Ian Penberthy
Series Editor: Richard Wiles
Picture research: Press Association Images
Design: Gravemaker + Scott

Colour reproduction by GMC Reprographics
Printed and bound in China by C&C Offset Printing Co. Ltd

Page 2: Pioneer aviator Samuel Franklin Cody prepares for the first British powered flight, which lasted 27 seconds and covered a distance of 1,390ft over Farnborough Common, Hampshire. Cody was American and, like his namesake, Buffalo Bill Cody (no relation), had lived the life of the cowboy and toured with a Wild West show, eventually settling in England in 1890. He developed man-carrying kites for the Army and was involved in the construction of the airship *Nulli Secundus I.*
16th October, 1908

Page 5: Just as in the First World War, women took on many of men's traditional roles during the Second World War while the men joined the military. Here women at an aircraft factory help to construct the Short Stirling, which was the Royal Air Force's first four-engine heavy bomber.
1942

Page 6: The beautiful dart-like, streamlined shape of Concorde was unique among commercial aircraft and always provoked interest whenever the machine appeared. This example has just been rolled out of the British Aircraft Corporation factory at Filton, near Bristol.
1st September, 1971

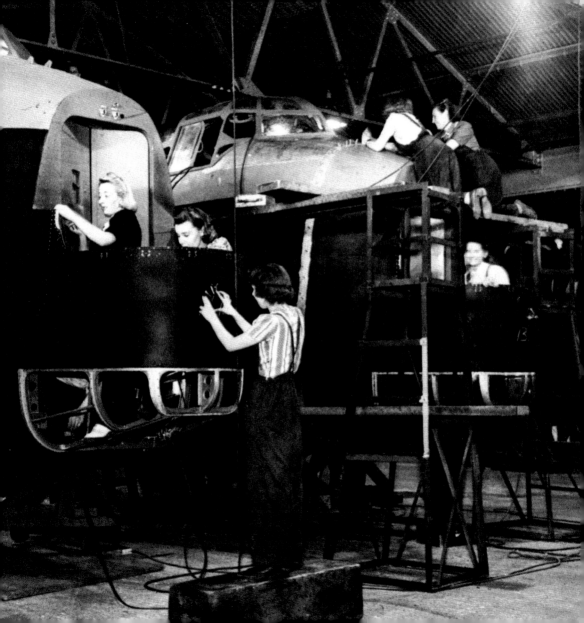

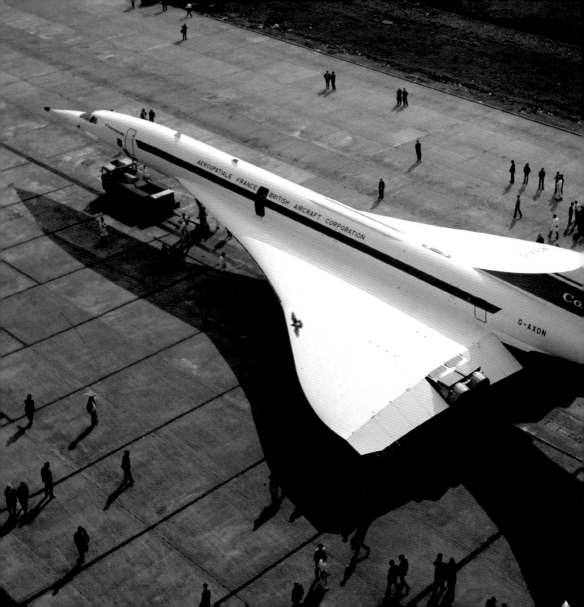

Introduction

Who knows how long man must have gazed at the birds, dreaming of flying, before in 1783 the Montgolfier brothers sent their first passenger carrying balloon into the air at Annonay in France. Certainly, Michelangelo had sketched a helicopter in the late 15th century, and there are records of a hang glider having been constructed and flown successfully in Spain during the late 9th century. Flight has probably fascinated man throughout his history.

Balloons soon became the most practical means of flying, but balloons have to go where the wind blows them. With the development of the internal-combustion engine in the late 19th century, however, it wasn't long before balloons were being fitted with propellers so that they could be guided through the air. The result was the airship, which rose to prominence in the early 20th century, initially for military use, but later as the first aerial transport capable of crossing oceans.

Airships, though, were slow leviathans that carried only a small payload and were difficult to manage on the ground. Like balloons, their progress could be hampered by the wind, and a series of accidents during the 1930s, culminating in the explosion of the German airship *Hindenburg*, destroyed confidence in them.

The true future of flight lay in heavier-than-air machines, gliders at first and then aircraft with engines and propellers that could take off, fly wherever desired and land all under their own power. The first of these took to the air in 1903, when Americans Orville and Wilbur Wright launched their Flyer at Kill Devil Hills, North Carolina. Their achievement inspired would-be aviators around the world, and before long a variety of weird and wonderful machines began to appear. Some were successful, others failed, but these were the first faltering steps in the development of a mighty international aviation industry that would revolutionise communication, transport and warfare, shrinking the oceans and continents, and helping man reach for the stars.

Throughout the 20th century, aviation developed rapidly, progressing from fragile machines of sticks and string that could barely lift their own weight to streamlined projectiles made from exotic materials and capable of travelling at three times the speed of sound, at heights that take them to the very edge of space. And during that time, through peace and war, the photographers of the Press Association have been there to record every step and stumble along the way.

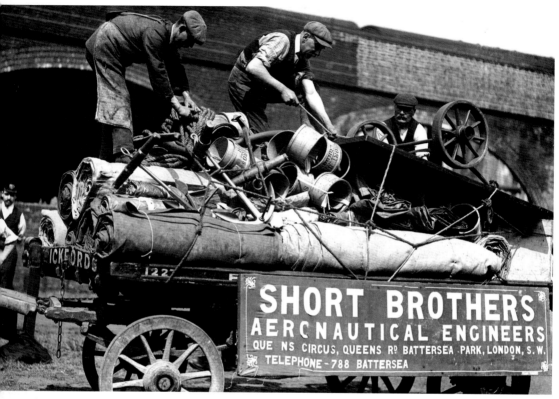

A Short Brothers gas balloon is packed on to a horse-drawn wagon outside the factory prior to being tested by the British Army. The Army used balloons for observing the enemy and directing artillery fire. The Short Brothers company was based in Battersea, south London, where it stored balloons for owners as well as manufacturing them.
1907

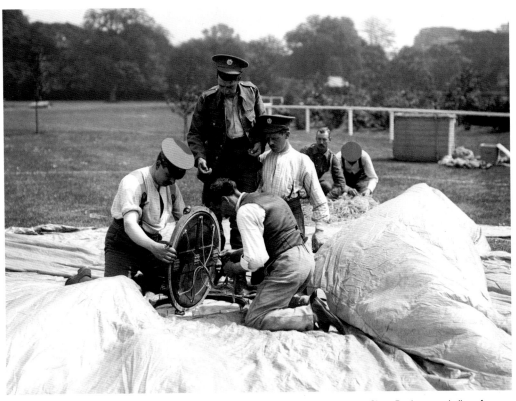

British soldiers prepare a Short Brothers gas balloon for flight. The Short brothers, Eustace and Oswald, had gained a contract to supply the British Army with balloons in 1902. Their business would become the first true aviation company in the world when they started to build aeroplanes in 1908.
1st May, 1907

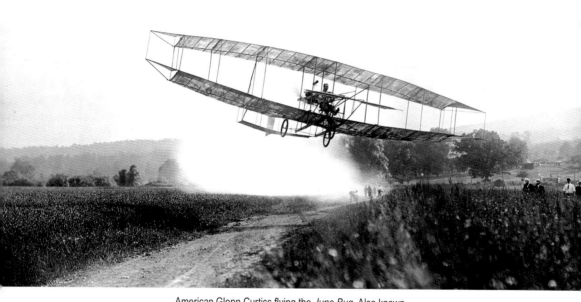

American Glenn Curtiss flying the *June Bug*. Also known as *Aerodrome No 3*, the *June Bug* had been designed by Curtiss and built by the Aerial Experiment Association (AEA), a group founded by inventor Alexander Graham Bell.
1908

Glenn Curtiss at the controls of the *June Bug*. Curtiss moved into aviation after building and racing motorcycles. He would go on to become an engine builder and a manufacturer of aircraft. His Curtiss Aeroplane and Motor Company is now part of the Curtiss-Wright Corporation. He died in 1930 following complications that developed after appendix surgery.

1908

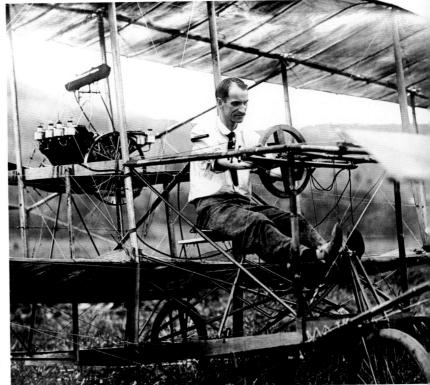

A group of 'aeronauts' poses for the photographer in front of a pair of gas balloons at Winchester, Hampshire. Although the first balloons had been inflated with hot air, they did not remain in the air for long because they were not equipped with their own burners. Consequently, in an attempt to prolong flight, balloonists turned to lighter-than-air gases instead, among them coal gas and hydrogen.

12th June, 1908

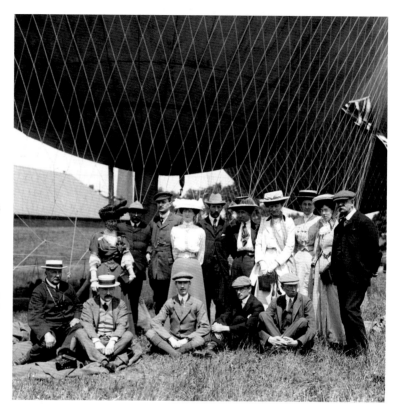

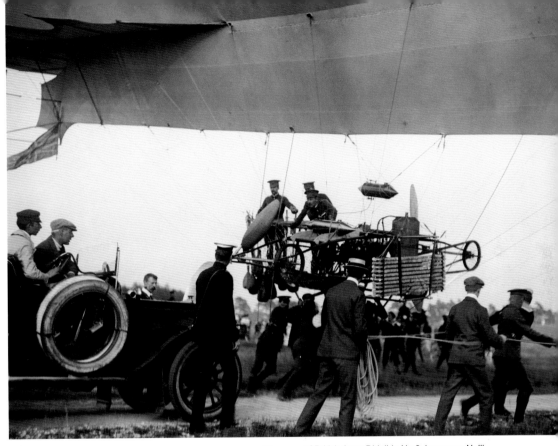

The crew of British Army Dirigible No 2, known as *Nulli Secundus II*, readies the craft for take-off. Parts of the semi-rigid airship's predecessor, *Nulli Secundus I*, Britain's first military aircraft, which had crashed, had been used in its construction, but the ship proved to be as fragile as its forebear and was only flown successfully once.
1st July, 1908

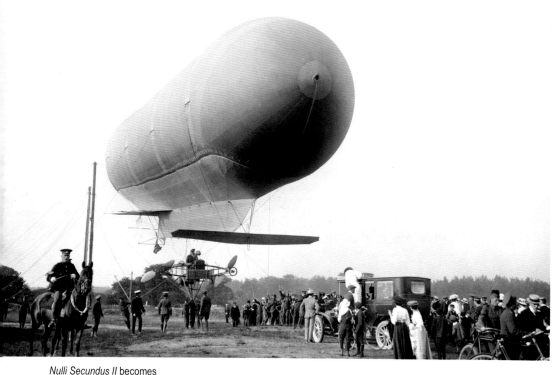

Nulli Secundus II becomes
airborne. This was the second
time that the airship had
attempted to fly, but the flight
lasted only 15 minutes, due to
a damaged water pipe, and the
craft was never flown again.
14th August, 1908

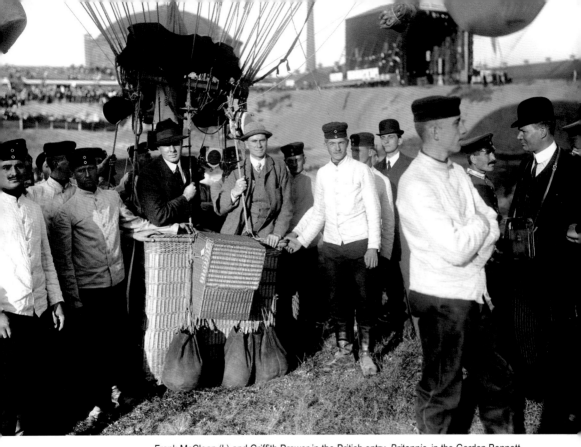

Frank McClean (L) and Griffith Brewer in the British entry, *Britannia*, in the Gordon Bennett Balloon Race of 1908. The international event for gas balloons had been inaugurated in 1906 and each year began from a different country. In 1908, the starting point was Berlin in Germany. That year, the race was won by Swiss entrants Theodor Schaeck and Emil Messner, who stayed aloft for 73 hours, a record that remained unbroken until 1995.
8th October, 1908

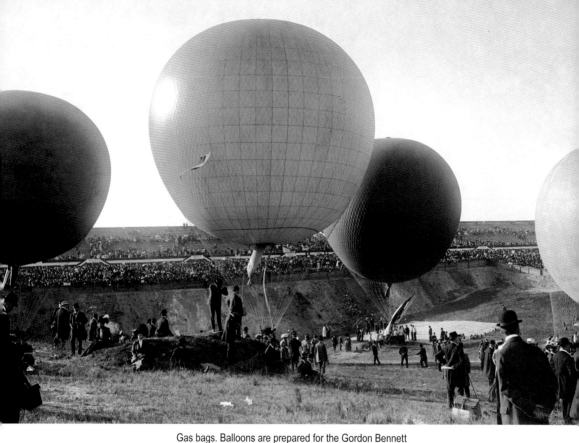

Gas bags. Balloons are prepared for the Gordon Bennett Race at the Schmargendorf gas factory in Berlin. At that time, the race was followed avidly by the newspapers, receiving the kind of attention that only the Olympic Games would attract today. And balloons were producing far more impressive performances than the recently developed aeroplane, in terms of flight duration, altitude and distance.
11th October, 1908

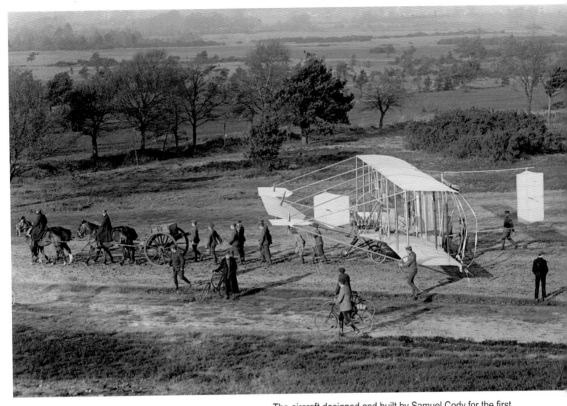

The aircraft designed and built by Samuel Cody for the first British powered flight is hauled into position for take-off on Farnborough Common, Hampshire. At the time, Cody was employed by the British Army, and his experiments had a military purpose. Accordingly, the new craft was named British Army Aeroplane No 1.
16th October, 1908

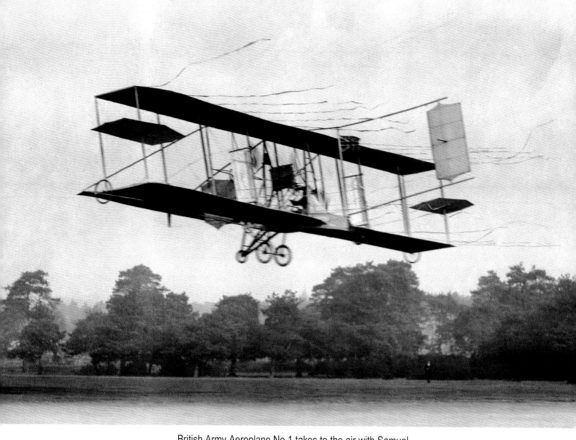

British Army Aeroplane No 1 takes to the air with Samuel Cody at the controls. The biplane was similar to that used by the Wright brothers, with booms fore and aft to carry the elevator and rudder. Unlike the Wrights' machine, it had a wheeled undercarriage. It was powered by a 50hp Antoinette engine that drove two pusher propellers.
16th October, 1908

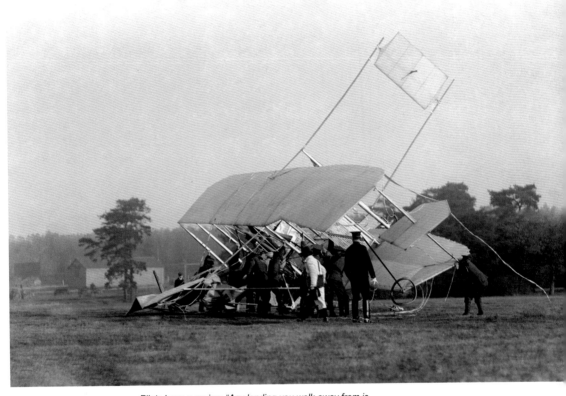

Pilots have a saying: "*Any landing you walk away from is a good one!*" Cody walked away from this one after his historic first powered flight and subsequently rebuilt the craft, eventually fitting a more powerful 60hp ENV engine, with which he made a 40-mile flight in 1909. Cody died in 1913 when the aircraft he was flying broke up in mid-air.
16th October, 1908

Famed American aviation pioneers Wilbur (L) and Orville Wright show how to construct a wing of one of their machines at the Short Brothers aeroplane factory at Shellbeach in Kent. The Wrights had granted Short Brothers a licence to manufacture the Wright Flyer in Britain, making the business the first aircraft manufacturing company in the world.
1909

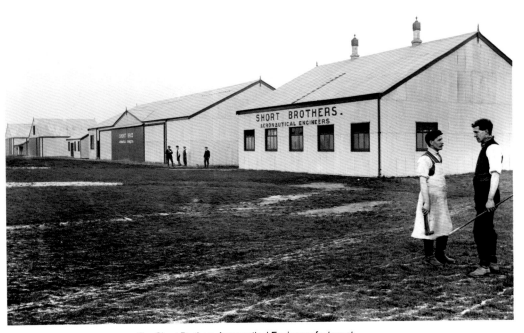

The Short Brothers Aeronautical Engineers factory at
Shellbeach on the Isle of Sheppey in Kent. The company
shared the airfield with the Aero Club (later Royal Aero
Club), whose members purchased six Wright Flyers from the
fledgling manufacturer.
1st July, 1909

Famous flyer. Louis Blériot in his Blériot XI aeroplane after crossing the English Channel and becoming the first man to fly a heavier-than-air machine over the body of water. He received a prize of £1,000 from the *Daily Mail* for the feat. His monoplane was powered by a three-cylinder Anzani engine of 25hp, and the crossing took 37 minutes.

25th July, 1909

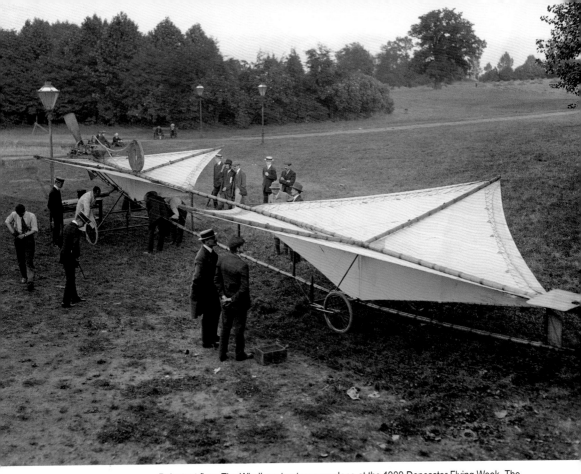

Reluctant flyer. The Windham tractor monoplane at the 1909 Doncaster Flying Week. The machine was to be piloted by Captain Walter George Windham, but unfortunately it collapsed when he sat in it for the first time. To add to his misfortune, when it had been fixed, he taxied it into a car, writing it off. The event took place on Doncaster race course, South Yorkshire, between the 15th and 23rd October. It was narrowly the first such event ever held in Britain.
15th October, 1909

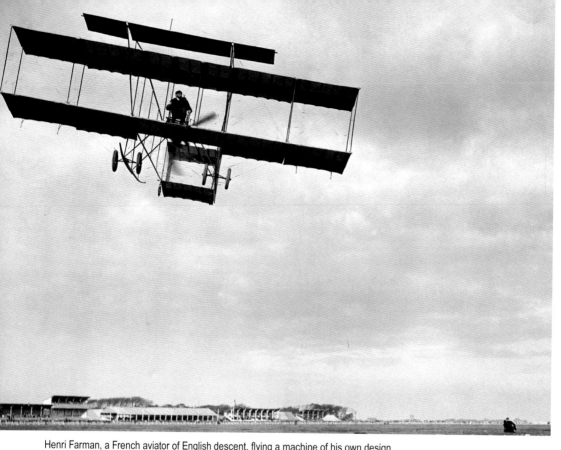

Henri Farman, a French aviator of English descent, flying a machine of his own design at Blackpool Flying Week, held at the Lancashire seaside resort between 18th and 26th October, 1909, at the same time as a rival event at Doncaster. Farman gained a number of early aviation records and, in partnership with his brother Maurice, became an important aircraft manufacturer during the early 20th century. The Farman Goliath of 1919 was the world's first long-distance airliner.

23rd October, 1909

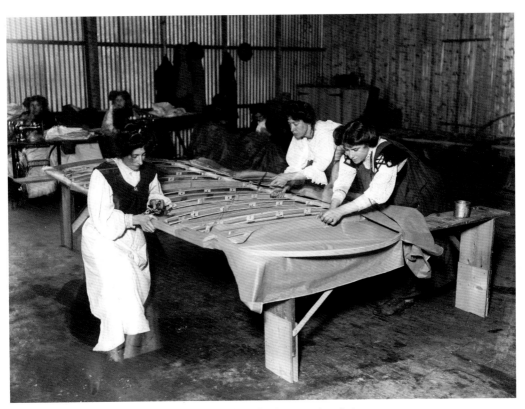

Women workers at the Short Brothers aeroplane factory, Shellbeach, Leysdown-on-Sea on the Isle of Sheppey. They are covering the delicate wooden framework with linen, which then will be treated with dope to make it taut. The result was a lightweight, but rigid structure.
1910

Pioneer aviator Alliott Verdon-Roe (R) stands in front of his Avro 1 Triplane outside his factory in Lea Marshes, north London. With him is his brother, Humphrey, and they are celebrating the formation of AV Roe and Company, one of the world's first aircraft builders. The company would become one of Britain's most famous and well-known aviation manufacturers, responsible for such iconic aircraft as the Lancaster and Vulcan bombers. **1910**

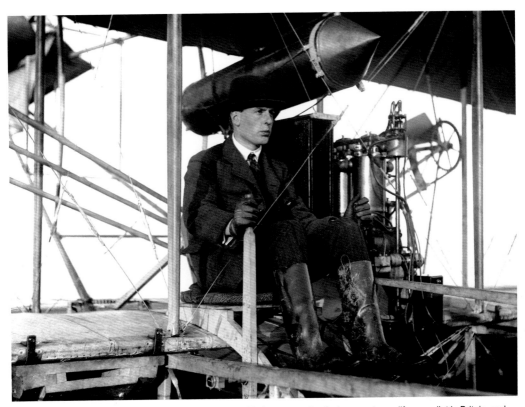

London-born John Moore-Brabazon was the first person to qualify as a pilot in Britain, and he is seen here on the day he gained his 'wings'. Later, to prove that pigs could fly, he put a small pig into a basket lashed to one of the struts of his aeroplane and took off. This was probably the first ever cargo carrying flight. Moore-Brabazon flew with the Royal Flying Corps during the First World War and was Minister of Aircraft Production in the Second World War. The giant Bristol Brabazon of 1949 was named after him.

8th March, 1910

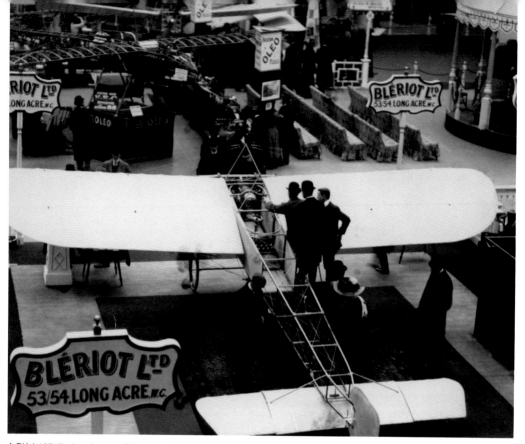

A Blériot XI displayed on the Blériot stand at Britain's first
Aero Exhibition at London's Olympia. In addition to selling his
proven monoplane machines, Blériot would go on to set up
flying schools at Brooklands and Hendon aerodromes.
11th March, 1910

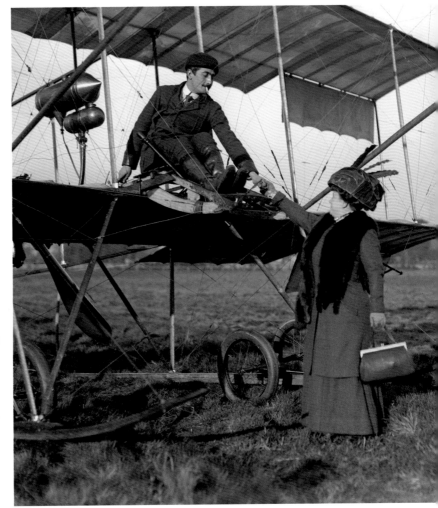

French pilot Louis Paulhan bids "*Au revoir*" to his wife before taking to the air in his Farman biplane. Paulhan had taught himself to fly in a Voisin machine in 1908, and in early 1910 he had toured the United States giving flying demonstrations. In April of that year, he won a prize of £10,000 offered by the *Daily Mail* to the first pilot to fly from London to Manchester within a period of 24 hours.

1st June, 1910

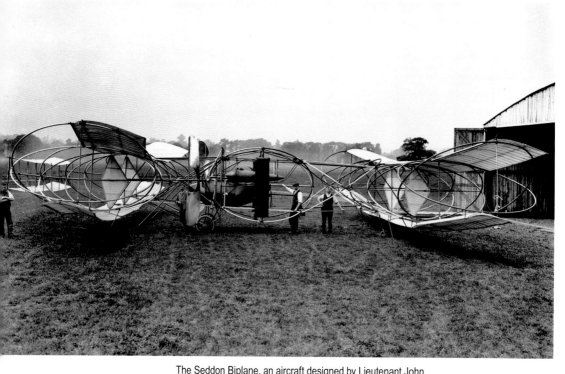

The Seddon Biplane, an aircraft designed by Lieutenant John Wilfred Seddon, RN and Mr AG Hackett. Called *The Mayfly*, it was a six-seat, twin-engine tandem biplane with a tubular-steel frame (unusual for early aircraft, which invariably had lightweight wooden frames) and the world's largest aeroplane at that time. It was tested at the Midland Aero Club's Dunstall Park flying ground at Wolverhampton late in 1910, but failed completely to emulate its name and later was broken up without ever having left the ground.
1st October, 1910

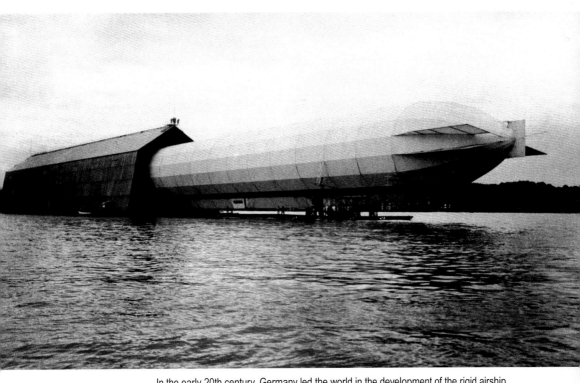

In the early 20th century, Germany led the world in the development of the rigid airship, thanks to the efforts of Count Ferdinand von Zeppelin, whose designs achieved such success that the name 'Zeppelin' became a generic term for the machines. The world's first commercial airline, Deutsche Luftschiffahrts-AG, operated services with Zeppelins prior to the First World War, and Germany made extensive use of airships during the war as bombers. Here the LZ-3, the first successful Zeppelin, enters its floating hangar on Lake Constance in southern Germany. A floating hangar was chosen because it could be aligned with the wind, easing the process of launching and retrieving the Zeppelin.
10th October, 1910

American Wilbur Wright, who, with his brother Orville, achieved the first flight of a powered, heavier-than-air machine at Kitty Hawk, North Carolina in 1903. Wilbur was to take the lead in a bitter patent battle against other early aircraft manufacturers in America, especially Glenn Curtiss. The argument centred on the methods by which aircraft could be controlled, the Wrights arguing that their patent covered all the various possible methods and that they should be paid by other manufacturers for licences to use those methods. Wilbur died of typhoid fever in May 1912, two years before the court finally ruled in the Wrights' favour.
1911

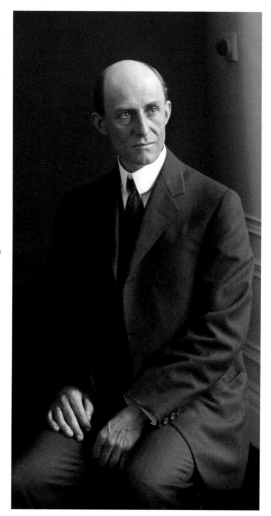

Facing page: Aviators Louis Blériot (R) and Adolphe Pégoud (C). The latter was Blériot's test pilot, and he would become the second man to loop the loop while testing a Blériot XI monoplane in 1913 (the first was a Russian, who had achieved the feat 12 days before). Subsequently, Pégoud flew for the French during the First World War, being shot down and killed, ironically, by one of his prewar students.
1911

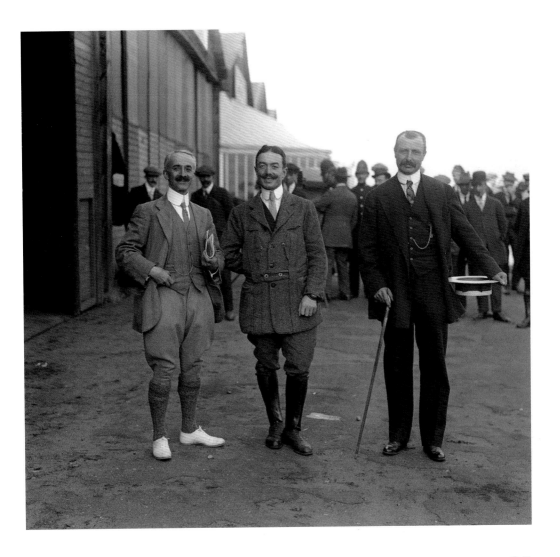

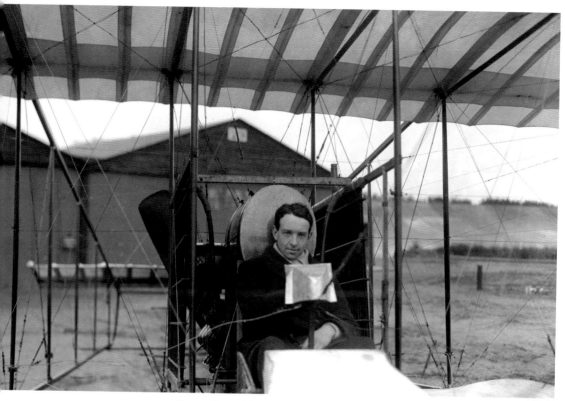

Thomas 'Tommy' Sopwith in his Howard-Wright biplane at Brooklands. Sopwith had taught himself to fly in an Avis monoplane in 1910 and was awarded his certificate in November of that year. A month later, he won a £4,000 prize for the longest flight from England to the Continent and used the winnings to set up a flying school at Brooklands. In 1912, he and several others would form the Sopwith Aviation Company, which would produce over 18,000 aircraft for the British during the First World War, including the famous Camel fighter.
1911

Leonard Mansfield Robinson, a 14-year-old naval cadet, became England's youngest aviator when he began learning to fly in a Deperdussin monoplane at Brooklands in 1911. A year later, he was responsible for designing an aircraft bombsight. Although rejected by the Admiralty, it used the same principles as later sights that were accepted.

1911

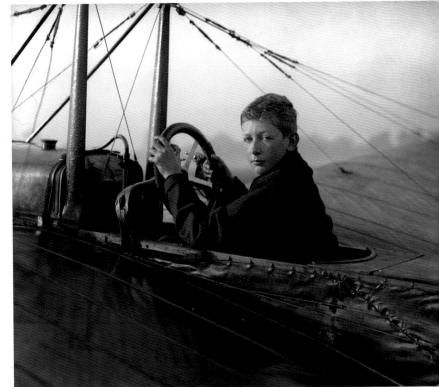

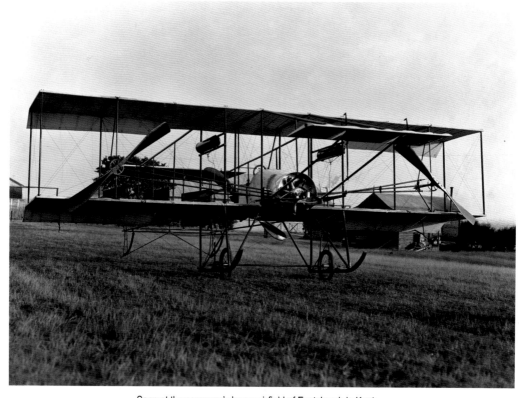

Seen at the company's home airfield of Eastchurch in Kent, the Short Brothers S-39, or Triple Twin, was the world's first twin-engine aeroplane. Its central fuselage was fitted with an engine at the front and another at the rear, the latter directly driving a single propeller. The front engine, however, drove two propellers mounted far out on the wing struts.
1st June, 1911

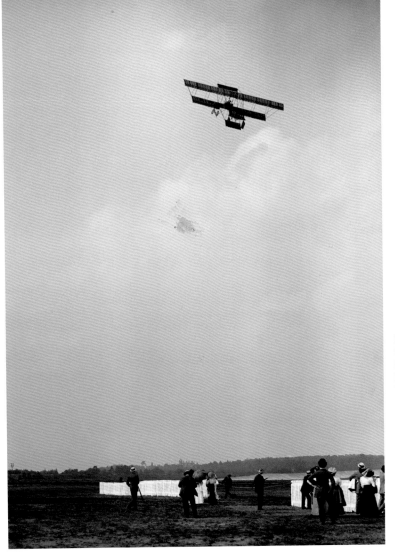

Douglas Graham Gilmour
flying a Bristol biplane at
Brooklands, near Weybridge
in Surrey. Gilmour had
learned to fly in Paris in
1909, but was a law unto
himself. His Royal Aero Club
certificate was suspended
after he flew low over the
crews taking part in the
Oxford and Cambridge
Boat Race, but he
continued to fly. He died
when his aircraft crashed
at Richmond in Surrey
on 17th February, 1912.
22nd July, 1911

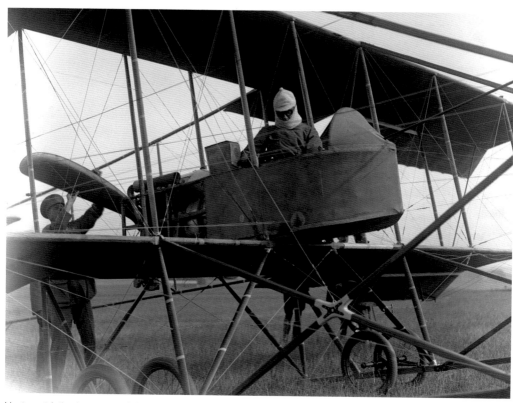

Lieutenant Arthur Longmore, of the Royal Naval Air Service, prepares for take-off during the first British Military Aeroplane Trials at Larkhill on Salisbury Plain, Wiltshire. Subsequently, Longmore transferred to the Royal Air Force and rose to the rank of Air Chief Marshal.

August, 1912

Cheridah de Beauvoir Stocks, the second British woman to gain a pilot's certificate, and Pierre Verrier during the first Ladies' Day aviation meeting at Hendon. Unfortunately, other women flyers chose not to attend, leaving Cheridah as the sole entrant. Then the wind was considered too tricky for a woman pilot, and a cross-country flight and speed run were cancelled. However, the pair won the Speed Handicap with Passenger event. Cheridah was seriously injured a year later while flying with another aviator, Sydney Pickles, and never returned to the air.

6th July, 1912

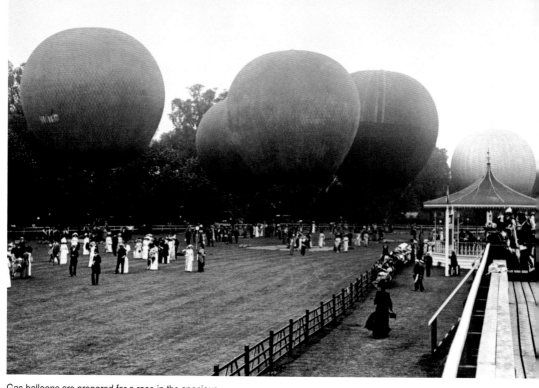

Gas balloons are prepared for a race in the spacious grounds of the Hurlingham Club at Fulham in southwest London. During the early 20th century, the club was a popular launching site for balloonists.
13th July, 1912

Dutch aviator Anthony Fokker sitting in a biplane glider. Fokker played a major role in aircraft development in the early decades of the 20th century, setting up a factory in Schwerin, Germany, where he built many of the aircraft used by the fledgling German Air Force during the First World War. Among them was the Fokker Triplane favoured by German air ace Baron von Richthofen. Fokker also developed the interrupter gear, which allowed a machine gun to fire through the arc of a propeller, aiding aerial combat.

12th October, 1912

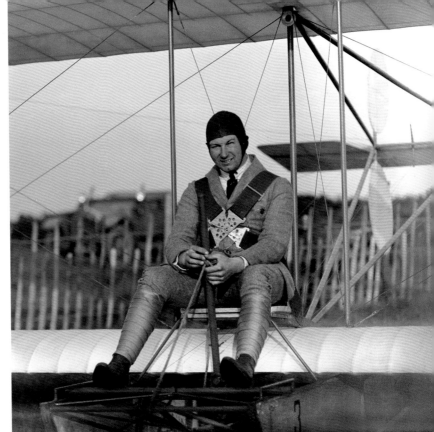

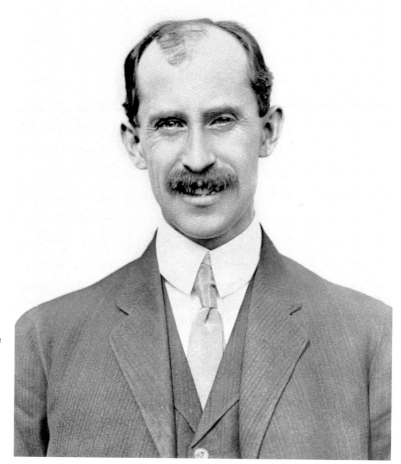

American aviation pioneer Orville Wright, who, with his brother Wilbur, had shown that heavier-than-air machines could fly in 1903. Orville became head of the Wright company upon Wilbur's death in 1912, but he was not a businessman and sold it in 1915. He made his last flight as a pilot in 1918, but continued to be involved in aviation, serving on many official boards and committees. He died from a heart attack on 30th January, 1948, at the age of 76.

1913

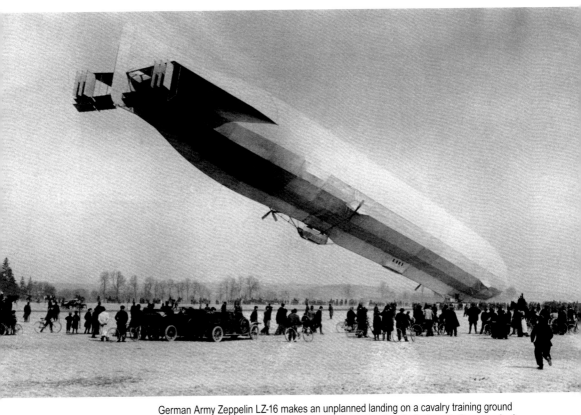

German Army Zeppelin LZ-16 makes an unplanned landing on a cavalry training ground at Luneville in France. The airship, which had been heading for its base in Germany, had strayed off course in bad weather and its reserves of hydrogen had become depleted, leaving the captain no option but to make an emergency landing. The military crew was returned to Germany overland, while civilian technicians were allowed across the border to repair the Zeppelin and fly it home, but not before the French had studied the machine carefully.
3rd April, 1913

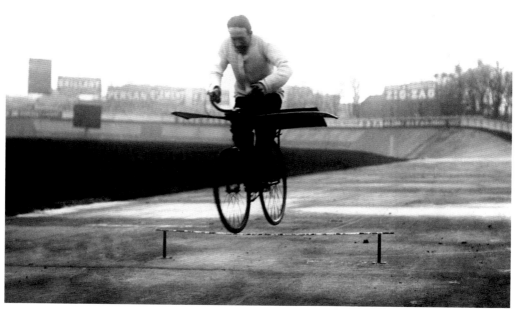

French cyclist Paul Didier tries to take flight on an *aviette* bicycle, although it is clear that the 'wings' of his machine would produce little, if any, lift. *Aviette* competitions were popular in France before the First World War, but no one actually succeeded in flying. In many cases, after furious pedalling, an *aviette* would simply be jumped over an obstacle by the rider, much as a BMX bike would be today.
1st June, 1913

Facing page: A mechanic prepares to swing the propeller and start the engine of Bentfield C. Hucks' Blériot monoplane. Hucks was the first English pilot to loop the loop, in November 1913, using a special 'looping' Blériot XI. He acted as a test and ferry pilot during the First World War, but died from the Spanish flu shortly before the end of the war, on 7th November, 1918.
1914

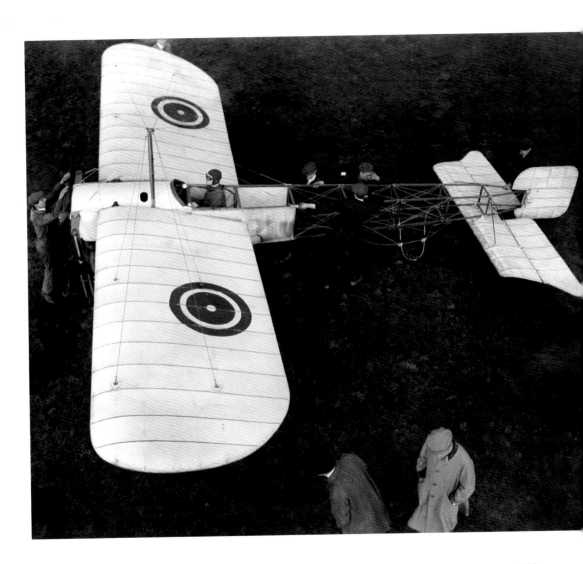

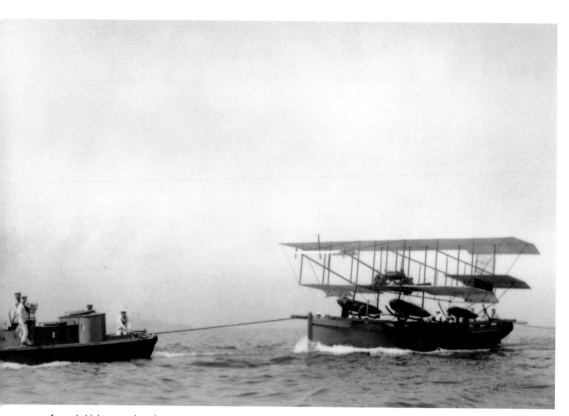

An early biplane, equipped
with floats to allow take-offs
and landings on water, being
towed on a lighter during
trials at Weymouth in Dorset.
1914

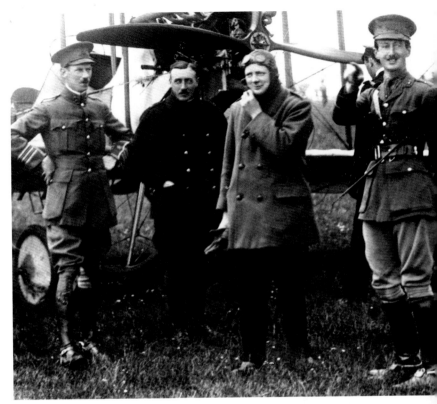

Winston Churchill (third L), then First Lord of the Admiralty, arrives at Portsmouth in an Army biplane piloted by Major Gerrard. The flight from the Central Flying School at Upavon, Salisbury Plain, a distance of 60 miles, had taken 20 minutes. Churchill had made several flights before from Upavon, but this was the longest to date.

29th April, 1914

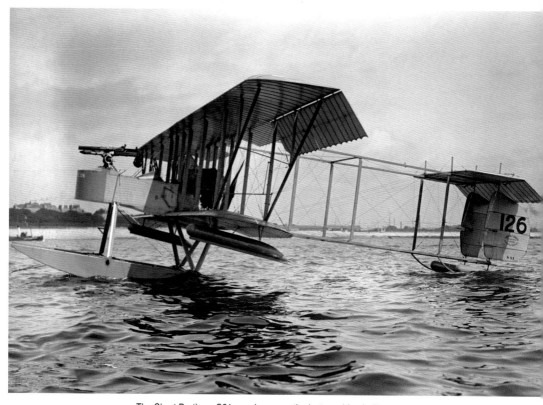

The Short Brothers S81 seaplane was the last machine built by the company with a pusher configuration, that is with the propeller at the rear of the fuselage. The aircraft was built specifically to test a Vickers semi-automatic 1½-pounder gun, which was mounted at the front of the fuselage. It was said that when the gun was fired, the recoil caused the aircraft to stop dead in the air and drop 500ft.

1st December, 1914

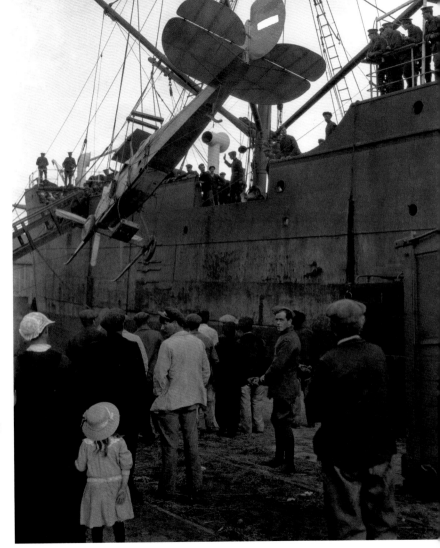

British aeroplanes belonging to the Royal Flying Corps are unloaded from a ship at a French port during the middle of the First World War. The wartime censor has masked the machine's serial number for security purposes.
1916

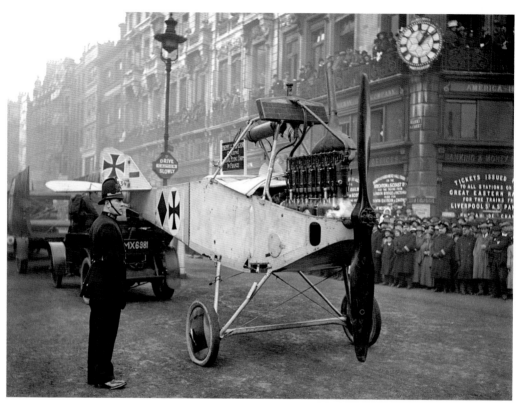

The spoils of war. The
fuselage of a German
aeroplane, captured in
France, is paraded along
Fleet Street in the City of
London during the Lord
Mayor's Show of 1916.
1st August, 1916

Baron Manfred Freiherr von Richthofen, the 'Red Baron',
seated in the cockpit of his Albatross DV fighter, with
other pilots of his squadron, Jagdstaffel III. Richthofen
was credited with downing 80 Allied aircraft before he was
shot down over the Somme, Northern France, during what
was known by pilots on both sides as 'Bloody April', 1917.
Richthofen's brother, Lothar, is seated at the front (fur collar).
1st April, 1917

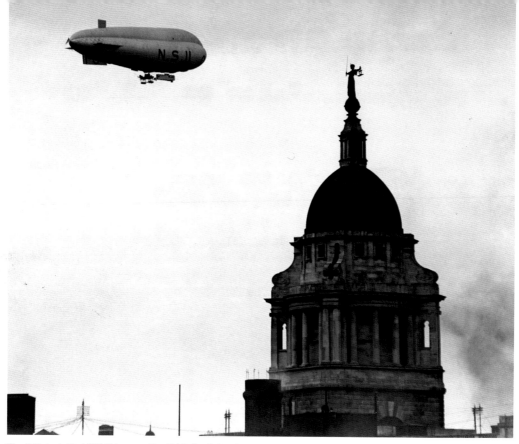

The British airship NS11 flying over the Old Bailey in London. The NS11 was a non-rigid airship, known as a 'blimp' in the USA, and was one of a series developed by the Royal Naval Air Service for long-range submarine patrols and convoy escort. The airship crashed with the loss of its crew off the Norfolk coast on 15th July, 1919. It was thought that a lightning strike had caused the hydrogen gas to explode.
1919

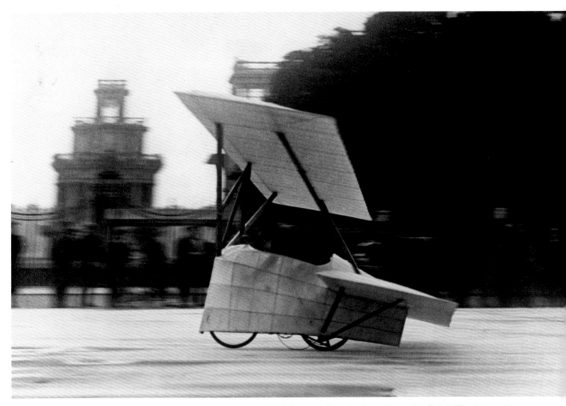

Pedal power. French champion cyclist Gabriel Poulain on his way to winning the Peugeot prize of 10,000 francs for a flight exceeding 10m in distance and 1m in height in a man-driven aircraft. His *aviette*, a bicycle with large wing and streamlined body, achieved four gliding flights of the required distance and height.

9th July, 1919

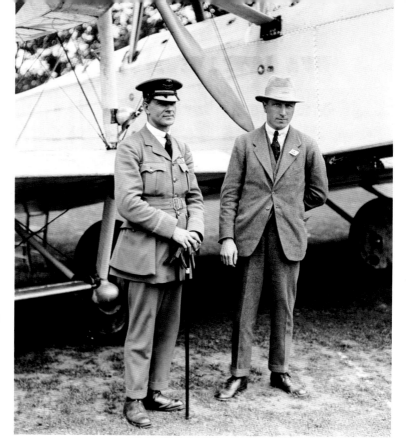

British aviators Arthur Whitton Brown (L) and John Alcock, who completed the first non-stop transatlantic flight from Newfoundland to Ireland in a Vickers Vimy bomber, covering 1,890 miles in just over 16 hours. Subsequently both men received knighthoods.
23rd August, 1919

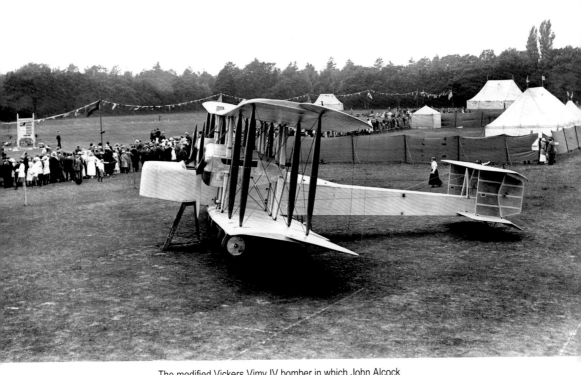

The modified Vickers Vimy IV bomber in which John Alcock
and Captain Arthur Whitton Brown crossed the Atlantic.
The machine was powered by a pair of 360hp Rolls-Royce
Eagle engines. To keep them running during the flight, it was
necessary for Brown to climb out on the wings frequently to
clear the air intakes of ice.
23rd August, 1919

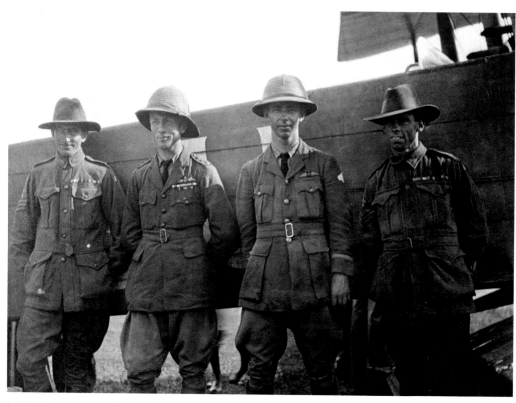

In 1919, the government of Australia offered a £10,000 prize for the first flight by Australians between England and Australia within a period of 720 hours. Six aircraft entered the race, which was won by a converted Vickers Vimy bomber with the registration G-EAOU (said to mean 'God 'Elp All Of Us'). Here the winning crew stands in front of the machine after arriving in Darwin. L–R: Sergeant Wally Spiers (mechanic), Captain Ross MacPherson Smith (pilot), Lieutenant Keith MacPherson Smith (co-pilot) and Sergeant Jim Bennett (mechanic).
10th December, 1919

South African officers of the Royal Air Force, Lieutenant Colonel Hesperus Andrias van Ryneveld (R) and First Lieutenant Quintin Brand, before setting out on a pioneering flight from England to South Africa in a Vickers Vimy, dubbed the *Silver Queen*, from Brooklands Aerodrome. Both men received knighthoods for their achievement, and on his arrival in South Africa, van Ryneveld established the South African Air Force.

4th February, 1920

American film actress Pearl White prepares for a flight from Cricklewood in London to Paris. White was known as the 'Stunt Queen' of silent films because she used to do all her own stunts, including flying aeroplanes, racing cars and swimming raging rivers. She was particularly known for the *Perils of Pauline* series.
1921

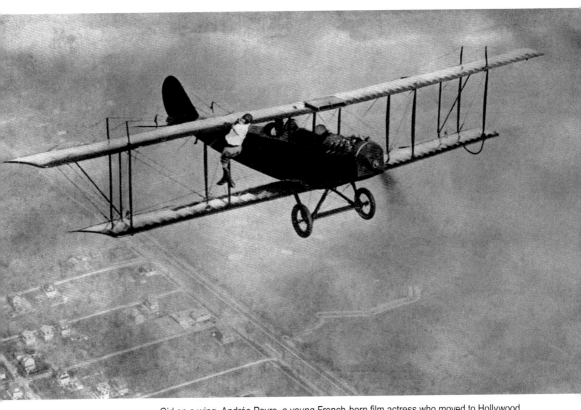

Girl on a wing. Andrée Peyre, a young French-born film actress who moved to Hollywood, was also an aviatrix who specialised in stunts that involved clambering over the wings of an aeroplane while travelling at a speed of 120mph. Her exploits featured in several films, but she gained a reputation of being too daring. For that reason, no one would rent her an aircraft for the 1923 thriller *Ruth of the Range*. Undaunted, she purchased her own machine and performed a number of spectacular stunts for the film.

1921

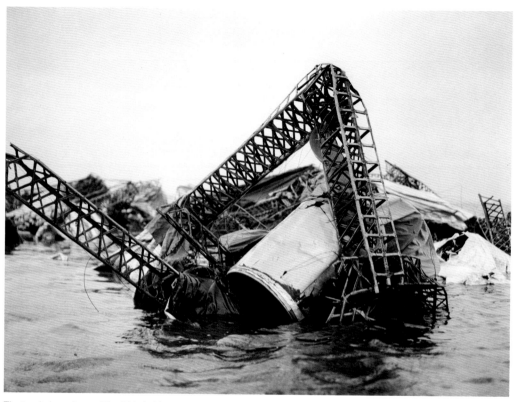

The tangled wreckage of the R38 airship, exposed at low tide in the Humber Estuary.
Built originally for the Royal Navy for long-range patrol work over the North Sea, the R38
was intended to be the first of a series of rigid airships, but with the ending of the First World
War only one was completed, and then because it had been sold to America. At the time
of its first flight in 1921, it was the largest airship in the world. The machine was on a trial
flight over Hull when it broke up in mid-air on 23rd August, 1921 with the loss of 27 Britons
and 16 Americans.
25th August, 1921

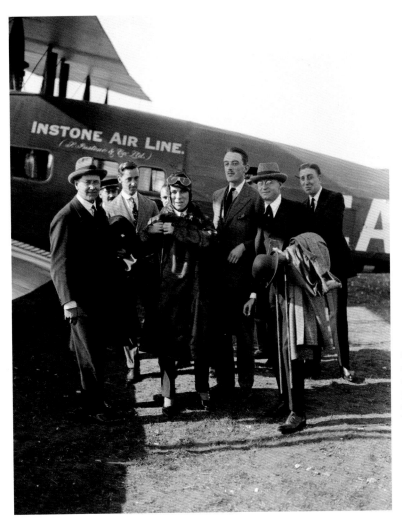

Only joking. Charlie Chaplin (in flying helmet and leather coat) jokingly dons a pilot's protective clothing for the camera before taking a flight from Croydon Aerodrome to Paris. Although flying was not the most comfortable of activities, by 1921 Instone Air Line could at least offer its passengers the comfort of an enclosed cabin.

5th October, 1921

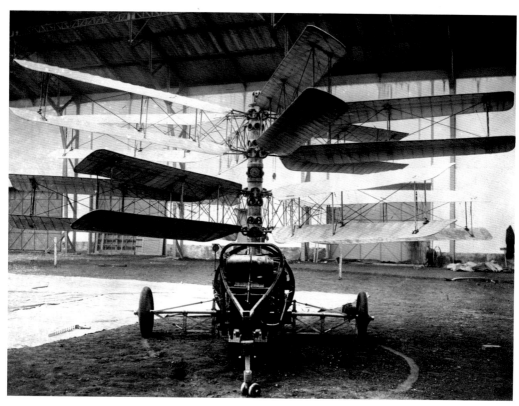

Developed by Raúl Pateras Pescara, this early helicopter
with coaxial rotors was one of several similar machines
built by the Argentine inventor between 1919 and 1923.
This particular example had just made a successful flight
near Paris. On 18th April, 1924, Pescara would make
a record breaking helicopter flight of 736m in 4 minutes,
11 seconds at a height of 1.8m.
18th February, 1922

A Type 16 Vulcan, a British single-engine biplane airliner, capable of carrying eight passengers, built by Vickers at Brooklands in Surrey. This particular machine was delivered to Douglas Vickers, MP, in September 1922, and it flew in the King's Cup Air Race that month. Despite its ungainly appearance and flying characteristics that gained it the soubriquet 'Flying Pig', it took seventh place. Four years later, in May 1926, it disappeared off the coast of Italy.

8th September, 1922

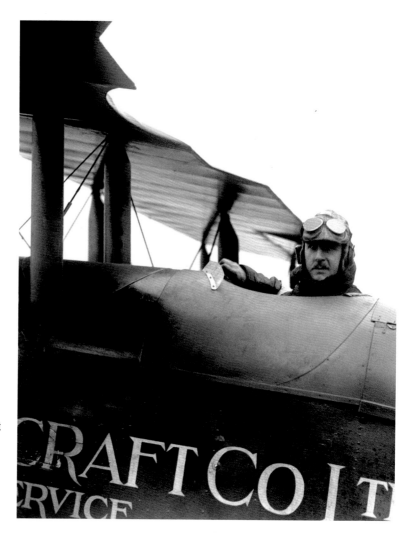

A determined looking Alan John Cobham looks down from the cockpit of a de Havilland DH9b single-engine biplane, in which he took third place in the Great Round Britain Air Race that terminated at Croydon Aerodrome. Cobb was the chief test pilot for Geoffrey de Havilland's aircraft manufacturing company.

9th September, 1922

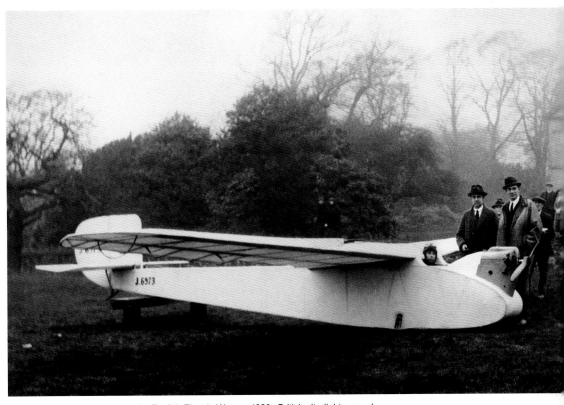

An English Electric Wren, a 1920s British ultralight monoplane, designed by William Manning and manufactured by the English Electric Company of Lytham St Annes, Lancashire. The machine was, in effect, a motorised glider. This particular aircraft, J6973, was built for the Air Ministry in 1920.

7th April, 1923

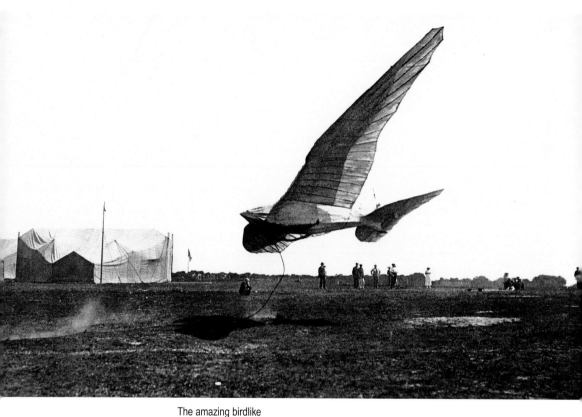

The amazing birdlike
Landes-Derouin Oiseau
Bleu (Blue Bird) becomes
airborne during a two-week
meeting for gliders and light
aeroplanes at Vauville in
Normandy, France.
11th August, 1923

A Vickers Vernon troop carrier of the Royal Air Force's No 70
Squadron in flight over the Pyramids in Egypt. The ungainly
looking machine was a descendant of the famous First World
War bomber, the Vimy. Earlier in the year, in February, this
machine had taken part in the first ever strategic airlift of
troops, when 500 soldiers were flown to Kirkuk in Iraq, where
Kurdish forces had overrun the town.

30th August, 1923

When it first flew in September 1923, the USS *Shenandoah* was the world's largest airship. Built for the United States Navy, the machine is seen having just left its giant shed at Lakehurst, New Jersey. A short while after this photograph was taken, the *Shenandoah* was damaged during a storm, which put the airship out of action until May 1924. It was laid up for a while in late 1924 and put back into service in 1925, but broke up in storm later that year with the loss of 14 lives.

17th January, 1924

The British airship R33, safely moored at the Royal Naval Air Station at Pulham, Norfolk, after its first flight in civilian guise. The machine was known colloquially by local residents as the 'Pulham Pig' and had been built originally for naval use during the First World War. The end of the war saw the machine allocated to more peaceful uses.
2nd April, 1925

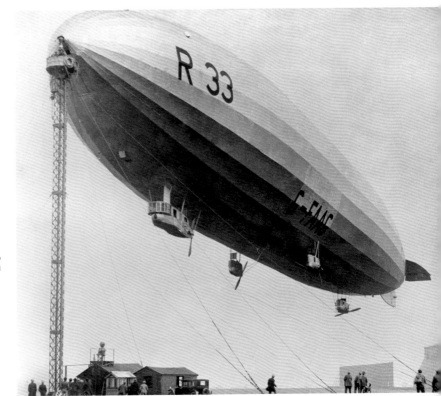

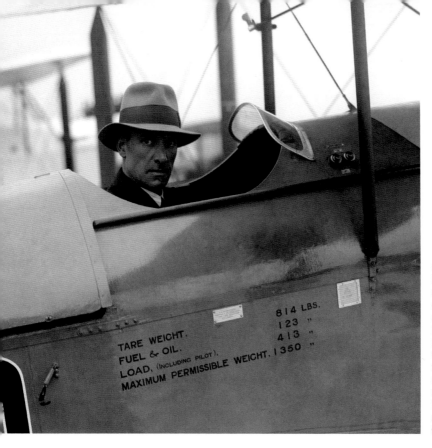

TARE WEIGHT. 814 LBS.
FUEL & OIL. 123 "
LOAD, (INCLUDING PILOT). 413 "
MAXIMUM PERMISSIBLE WEIGHT. 1350 "

Captain Geoffrey de Havilland, aviation pioneer and engineer, in the cockpit of a de Havilland DH60 Moth at the 1926 King's Cup Air Race. His company would make a major contribution to aviation throughout the 20th century, being responsible for many iconic aircraft, including the Tiger Moth, Mosquito, Vampire and Comet.
9th July, 1926

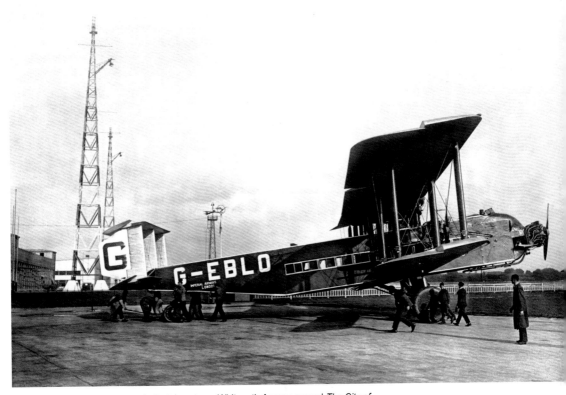

A giant Armstrong Whitworth Argosy, named *The City of Birmingham* and belonging to Imperial Airways, arrives in Berlin, Germany. At the time, the Argosy was the world's largest commercial aircraft. It had three engines and could carry 18 passengers. Imperial Airways had removed two passenger seats, however, and replaced them with a bar operated by a steward.

27th August, 1926

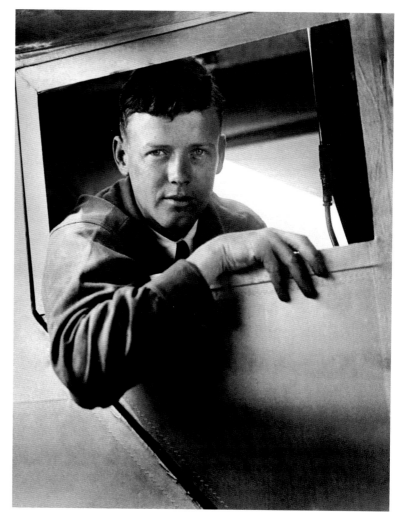

Daring young man. Youthful American aviator Captain Charles Lindbergh peers from the cramped confines of his aircraft, the *Spirit of St Louis*, after landing at Croydon Aerodrome on his way to Southampton after his record breaking non-stop flight from New York to Paris. At Southampton, he would join the USS *Memphis*, which would carry him to Washington, where President Calvin Coolidge would award him the Distinguished Flying Cross.
28th May, 1927

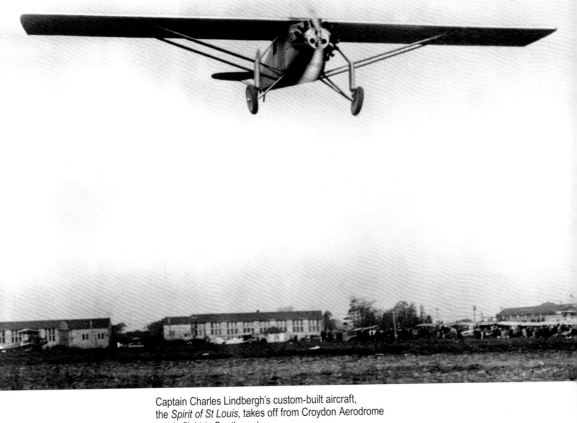

Captain Charles Lindbergh's custom-built aircraft,
the *Spirit of St Louis*, takes off from Croydon Aerodrome
on his flight to Southampton.
28th May, 1927

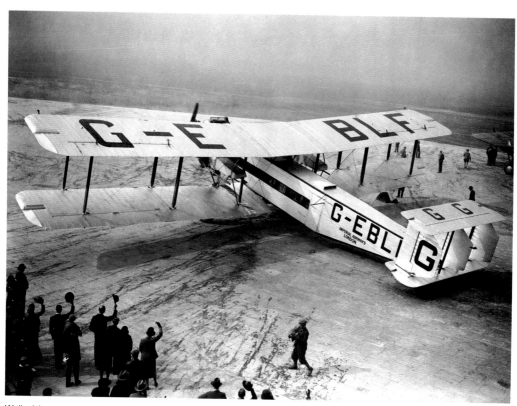

Well-wishers wave goodbye as Imperial Airways' airliner
City of Glasgow, an Armstrong Whitworth Argosy, taxis
away from the terminal building at Croydon Aerodrome on its
departure for a flight to Karachi, India.
30th January, 1929

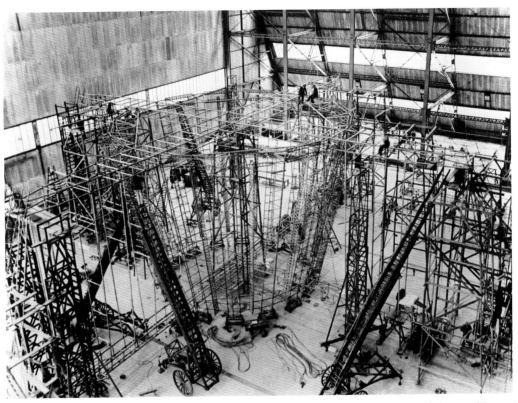

The framework for the tail section of Britain's R101 airship being assembled in one of the massive hangars at the Royal Airship Works, Cardington in Bedfordshire. The machine was one of two craft (the other was the R100) that were intended to be the forerunners of a fleet of airships that would operate commercial air services throughout the British Empire. That dream came to an end in October 1930, when the R101 crashed on its maiden overseas flight with the loss of 48 lives.

17th May, 1929

A flight of three Royal Air Force fighter aircraft takes to the air during the Air Pageant at Hendon Aerodrome, north London. The public flocked to such air shows, where they could inspect the latest machines and be thrilled by the daredevil exploits of the pilots.

13th July, 1929

Palestinian Scouts admire an Avro 504 two-seat biplane at Croydon Aerodrome. The machine was favoured by the Royal Air Force and civilian flying schools for training pilots. It had first appeared at the beginning of the First World War and remained in production for 20 years.
26th July, 1929

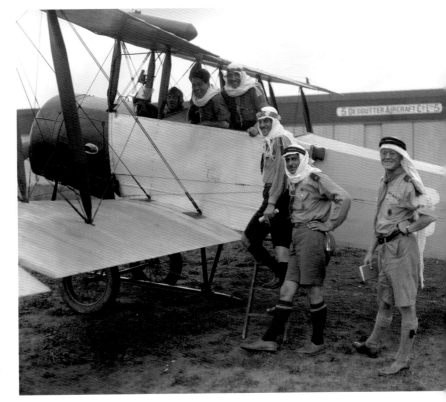

Sir Sefton Brancker (C), British Director of Civil Aviation and chairman of the Royal Aero
Club, greets Louis Blériot at Dover on the completion of the latter's flight across the English
Channel to commemorate his original historic flight of 1909. He had travelled in the very
latest of Blériot machines, a Blériot 127 bomber of the French Air Force, and is seen standing
in one of the gunners' positions at the rear of the engine nacelles.
27th September, 1929

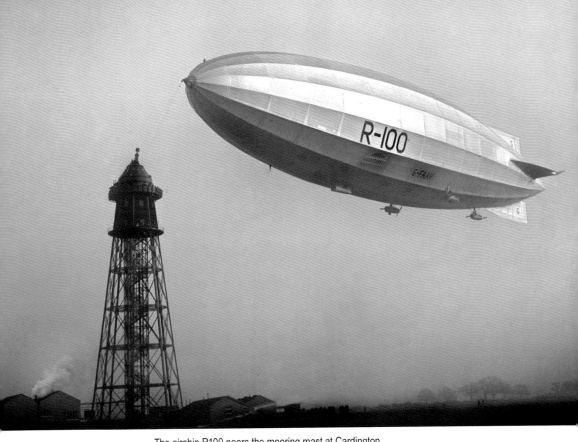

The airship R100 nears the mooring mast at Cardington, Bedfordshire during its maiden voyage from the airship station at Howden in Yorkshire. Among those who had worked on the construction of the craft were designer Barnes Wallis and mathematician Nevil Shute Norway, better known as Nevil Shute, author of *A Town Called Alice*.

12th December, 1929

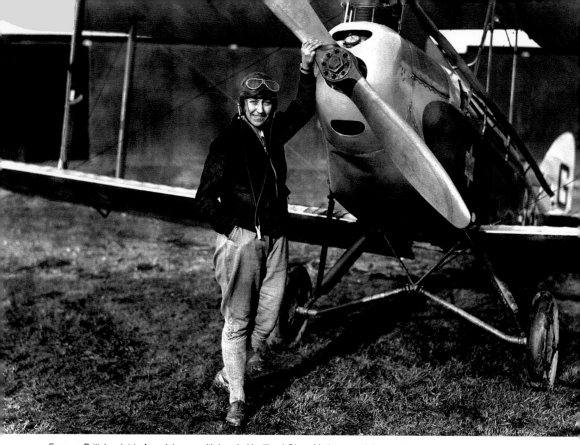

Famous British aviatrix Amy Johnson with her de Havilland Gipsy Moth, named *Jason*, at the London Aeroplane Club, Stag Lane, north London. Having qualified as a pilot, Amy went on to become the first woman to gain a ground engineer's licence. In May 1930, she would become the first woman to fly solo from England to Australia, going on to gain several other records and marry fellow long-distance aviator Jim Mollison. She would lose her life on 5th January, 1941, when the aircraft she was ferrying for the Air Transport Auxiliary crashed in the Thames Estuary.
10th January, 1930

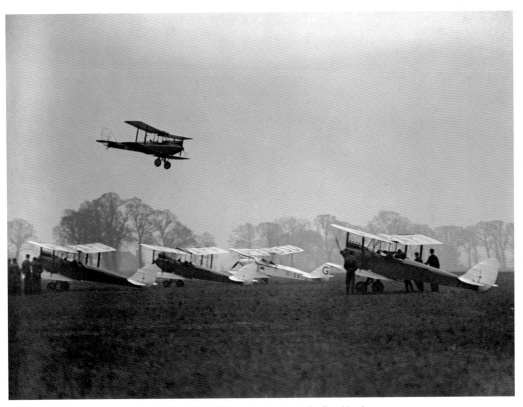

De Havilland Moth biplanes, belonging to the Brooklands
School of Flying, on the airfield at the centre of the famous
motor racing circuit in Surrey. The Moth was a popular club and
private machine, and the school was an agent for the company.
5th April, 1930

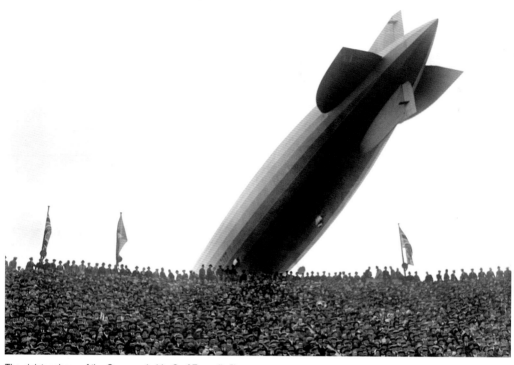

The sinister shape of the German airship *Graf Zeppelin* flies low over Wembley Stadium during the FA Cup Final of 1930. The craft was making a short overflight of London before heading for the airship base at Cardington, Bedfordshire. Its presence was not appreciated by Londoners, however, who remembered such machines bombing the city during the First World War. The crowd at Wembley jeered the airship, but the crew thought they were cheering and remained over the stadium for longer than originally intended.
26th April, 1930

Facing page: On a wing, with a prayer. Royal Air Force aircrew members receive parachute training aboard obsolete Vickers Vimy bombers. The men stood on small platforms attached to the outer wing struts of the machines while holding on tightly to the struts. At the given signal, they released their parachutes, which pulled them from the platforms.
1st July, 1930

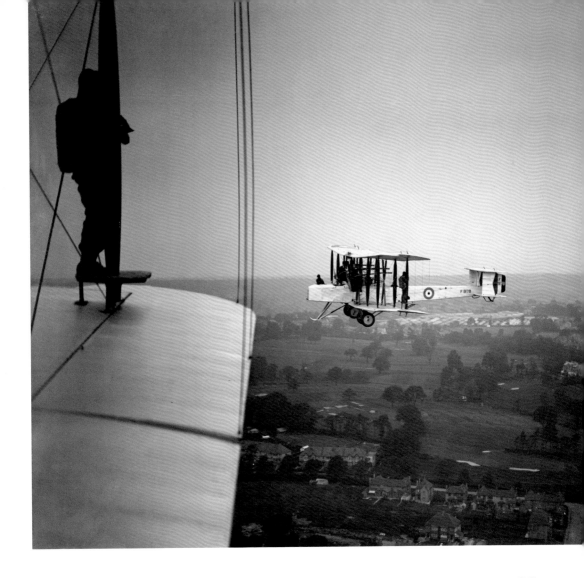

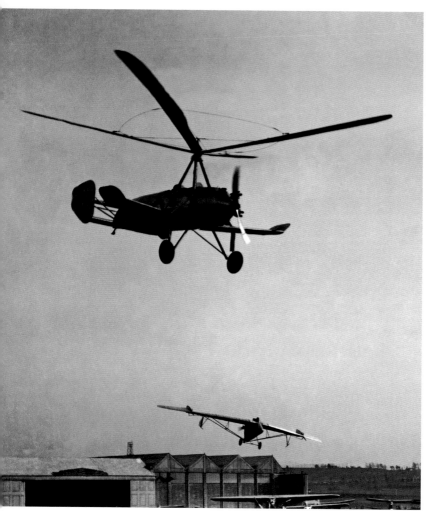

Strange craft. A Cierva C19 autogiro descends to land, while a Westland-Hill Pterodactyl experimental aircraft flies low in the background. The autogiro was a cross between a helicopter and an aeroplane, using the rotor simply to provide lift while the engine drove a conventional propeller. It was the original STOL (short take-off and landing) machine. The Pterodactyl was a tail-less aircraft that eschewed conventional control surfaces in favour of fully moving wing tips.
1st October, 1930

The skeletal remains of the centre section of the airship R101. On its maiden overseas voyage to India, the ship had crashed and caught fire near Beauvais, France with a loss of 48 lives, including those of Lord Thomson, Secretary of State for Air and Sir Sefton Brancker, Director of Civil Aviation. The ship had many design faults leading to erratic flight characteristics, and it had dived into the ground.
5th October, 1930

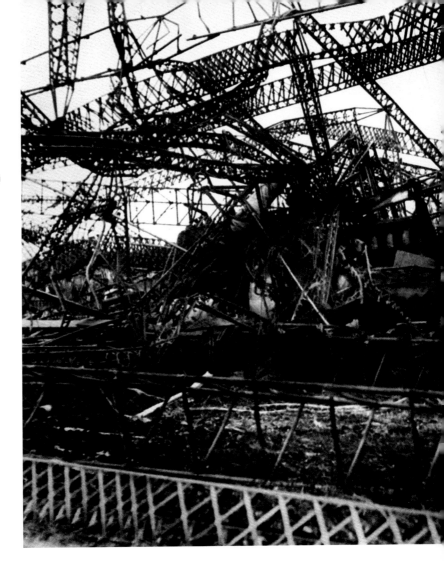

A flight of three Royal Air Force Hawker Hart two-seat biplane bombers, 900 of which were built at the Hawker factory at Brooklands in Surrey. The machine was the most widely used light bomber of its time and gave rise to several variants. Large numbers of these aircraft were used by the RAF for policing duties on the North West Frontier of British India during the 1930s.

1st November, 1930

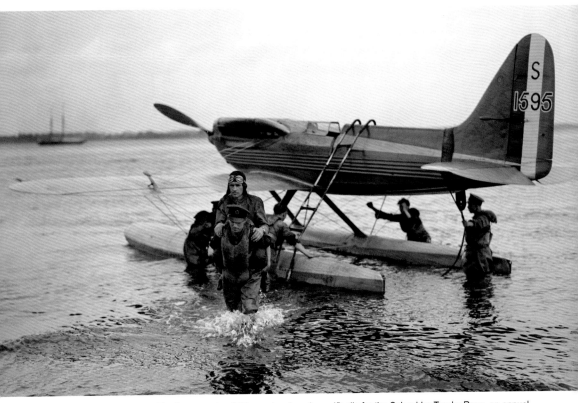

The Supermarine S6B was developed specifically for the Schneider Trophy Race, an annual competition for seaplanes inaugurated in 1913 by financier Jacques Schneider. Here Flight Lieutenant Freddy Long, RAF, one of its pilots, is carried ashore after a successful trial flight. Another team member, Flight Lieutenant John Bootham, would win the race over the Solent on 14th September, 1931. After the competition, Flight Lieutenant George Stainforth would use the machine to break the world airspeed record twice, setting it at 407.5mph.

11th August, 1931

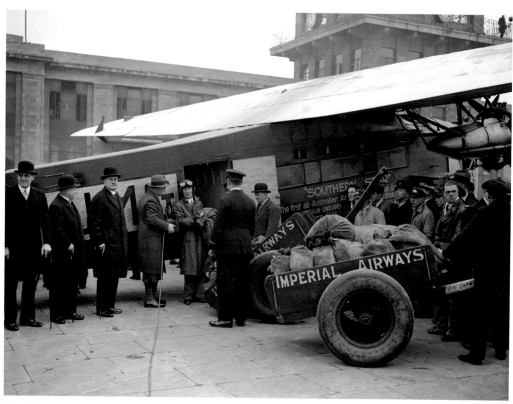

Famed Australian long-distance aviator Charles Kingsford Smith (wearing goggles) arrives at Croydon Aerodrome in a three-engine Fokker FVII/3m airliner, named *Southern Star*, with Christmas mail from Australia. Kingsford Smith carried out a number of pioneering trans-ocean flights, but on 8th November, 1935 his aircraft disappeared while flying over the Andaman Sea, off India, during an attempt to break the England–Australia speed record.
16th December, 1931

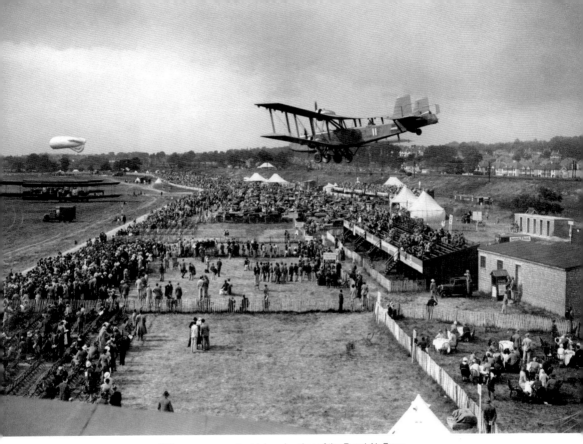

With a roar, a massive biplane bomber of the Royal Air Force flies low over the crowd during the Hendon Air Pageant of 1932. One of the attractions of the event was a low-level 'attack' by Vickers Virginia bombers on a group of giant skittles, using practice bombs.

25th June, 1932

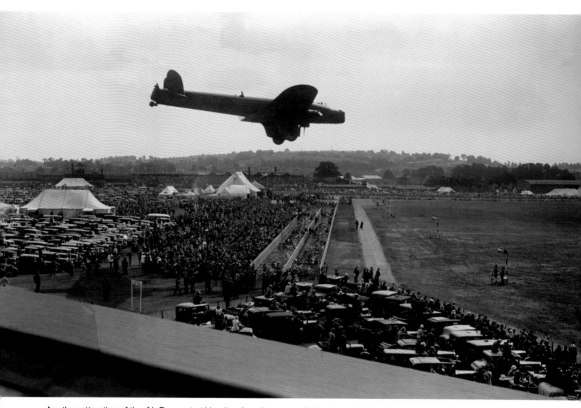

Another attraction of the Air Pageant at Hendon Aerodrome, north London was the opportunity to see the very latest of RAF equipment, such as this Fairey Hendon heavy bomber. The Hendon, which carried a crew of four, showed how aircraft design was moving away from the struts and bracing wires of the biplane to the more streamlined shape of the monoplane. It was the first all-metal, low-wing machine to enter RAF service.
25th June, 1932

Aviation • Britain in Pictures

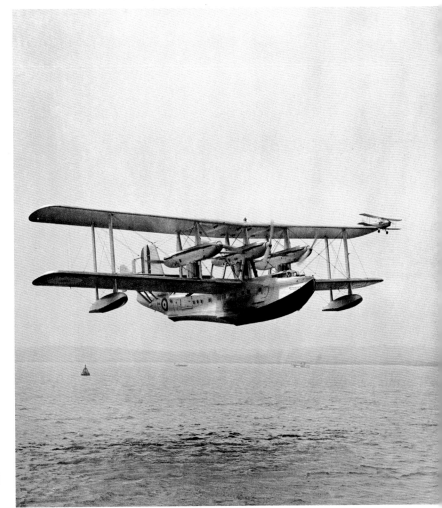

The Short S14 Sarafand, a six-engine British biplane flying boat, was designed for long-range ocean patrol work. When it was built in 1932, it was the largest aircraft ever constructed in the UK. Only one of these huge machines was ever built, however, and it was relegated to test flying at the Marine Aircraft Experimental Establishment at Felixstowe, Suffolk.
9th August, 1932

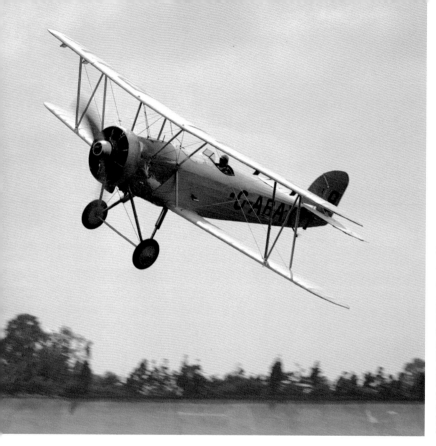

A civil registered Hawker Tomtit training biplane flying over Brooklands Aerodrome, home of the Hawker company. The Tomtit had been designed in 1928 to meet a Royal Air Force specification by Sydney Camm, chief designer at Hawker, who would go on to pen the famous Hurricane fighter. The Tomtit had an all-metal framework, although it was covered in fabric in the traditional manner.
1st June, 1933

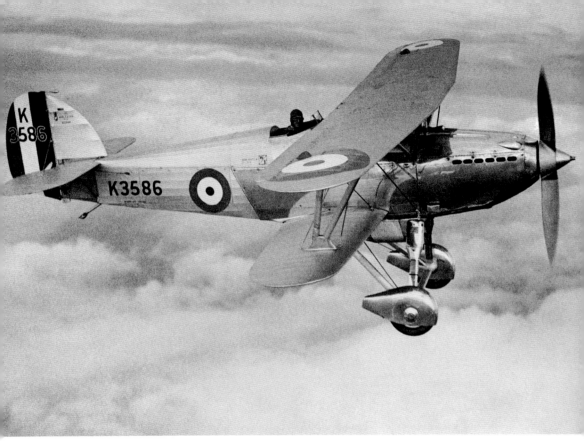

The Hawker Fury of 1931 was the Royal Air Force's first
fighter aircraft capable of exceeding 200mph. Seen here is
the High Speed Fury, an experimental prototype, which had
been developed to test a number of revised design features
aimed at improving speed and rate of climb. It was powered
by a 690hp Kestrel Mk 4 engine. Many of its features were
incorporated in the Fury Mk 2.
8th February, 1934

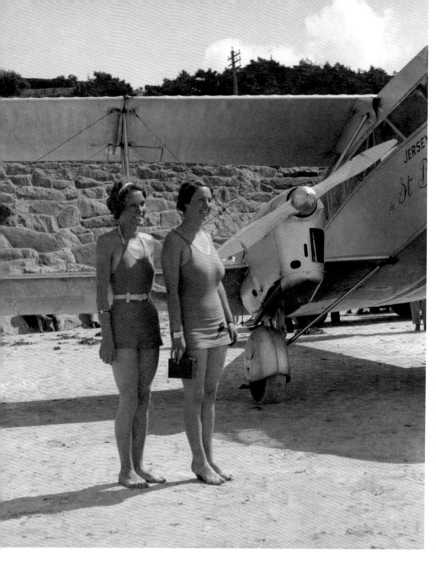

Sun, sea and…aeroplanes. Two young women dressed for the beach find their favourite sunbathing spot occupied by a Jersey Airways de Havilland DH84 Dragon airliner. The airport on the island of Jersey in the Channel Islands was not built until 1937, so before then aircraft had to use the long sandy expanse of St Aubin's beach.

1st August, 1934

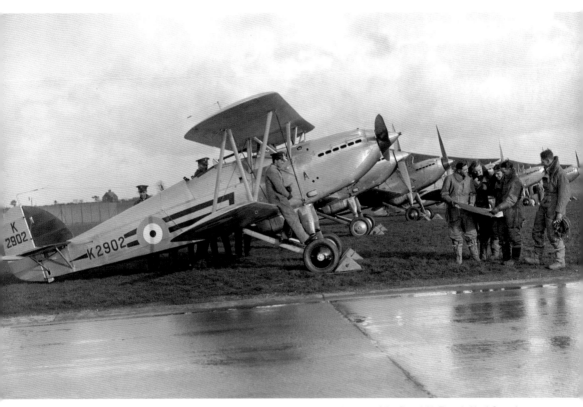

Hawker Fury fighters of the Royal Air Force's No 1 Squadron at Biggin Hill Aerodrome, where they were based for a 24-hour winter exercise extending from Clacton on Sea on the east coast all the way around to Beachy Head on the south coast. During the 1930s, No 1 squadron was renowned for its aerobatic displays, which it gave throughout the UK.
18th February, 1936

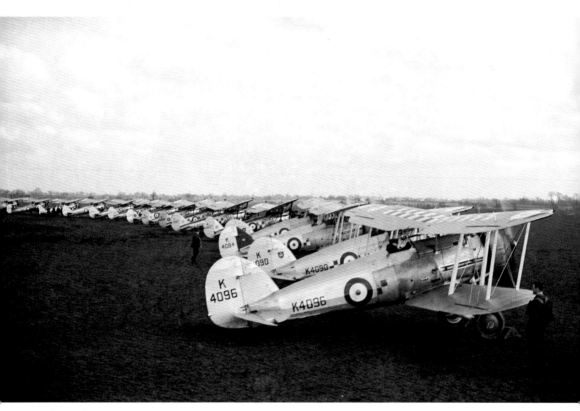

Gloster Gauntlet fighters belonging to the Royal Air Force's No 19 Squadron. The Mk 2 version of this biplane was just coming into service in 1936, and the four machines closest to the camera are of the latest model, no doubt the mounts of senior officers. The Gauntlet was the last open-cockpit fighter to enter RAF service.

1st March, 1936

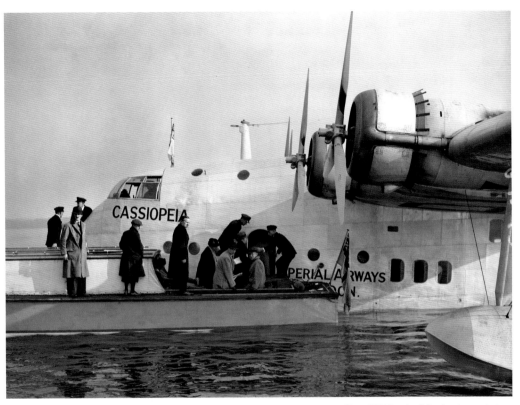

Passengers are helped aboard *Cassiopeia*, a giant Short S23 Empire flying boat operated by Imperial Airways (later BOAC). The machine was about to set off on its maiden flight from Southampton to Alexandria in Egypt. The Empire series of flying boats was built to serve Imperial Airways' routes to the colonies in Africa and Australia. The S23 could carry 17 passengers and five crew. It was also operated by the Australian airline Qantas and Tasman Empire Airways of New Zealand.
26th January, 1937

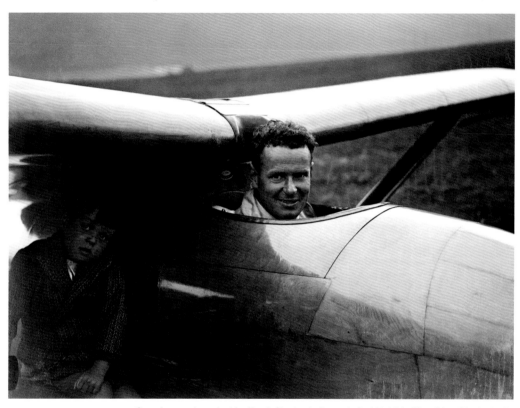

Speedway motorcycle rider Frank Charles in the cockpit of his Kirby Kite glider. Charles had bought the glider in November 1935, but had never flown before. To the amazement of his friends at Barrow in Furness Gliding Club, he taught himself to fly the machine within two months, having first attempted a couple of ground hops. By the end of January 1936, he was making soaring flights of an hour's duration and soon began flying cross-country. He was killed on 15th July, 1939 while competing in a gliding competition.
19th June, 1937

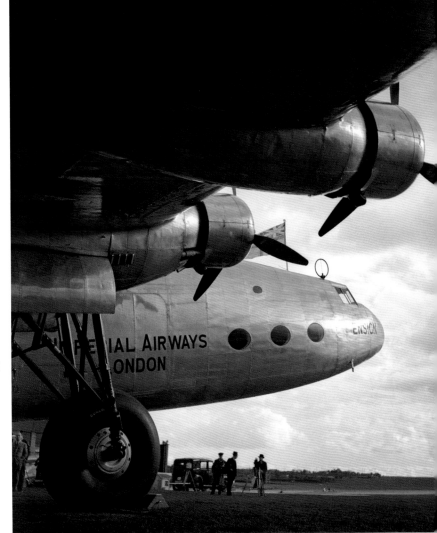

An Armstrong Whitworth AW27 Ensign airliner of Imperial Airways. The four-engine machine, which could carry 40 passengers, was developed to operate on the airline's overseas routes to Africa and Australia, working in conjunction with the company's Short Empire flying boats. This machine is seen in mid-1937, while still under test. It would not make its maiden overseas flight until January of the following year.

30th July, 1937

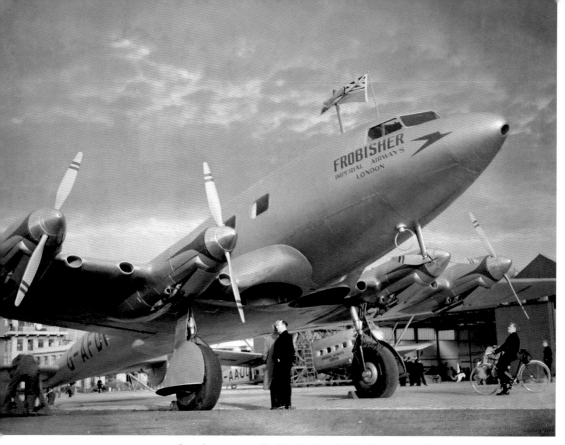

One of seven streamlined de Havilland DH91 Albatross aircraft designed originally as transatlantic mail carriers. This example, *Frobisher*, is a passenger variant with seating for 22. The machine was notable for the plywood/balsa sandwich construction of its fuselage, which provided a lightweight rigid structure. The same method was used to construct the famous Mosquito bomber. *Frobisher* was destroyed on the ground during a German air attack on Whitchurch Airport, Bristol on 20th December, 1940.

1938

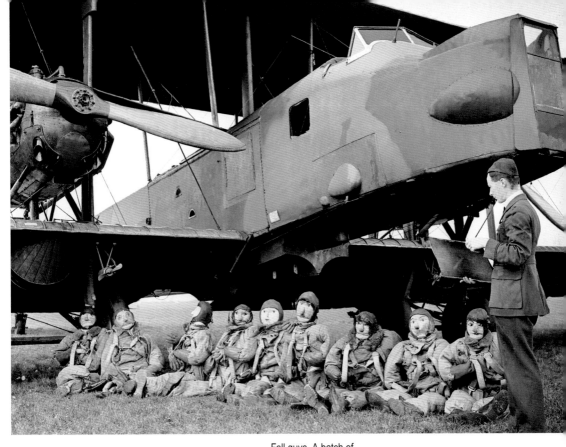

Fall guys. A batch of
dummies made from
sandbags await loading onto
a Vickers Virginia bomber
at Hendon Aerodrome, north
London. The dummies were
used to test parachutes.
28th February, 1938

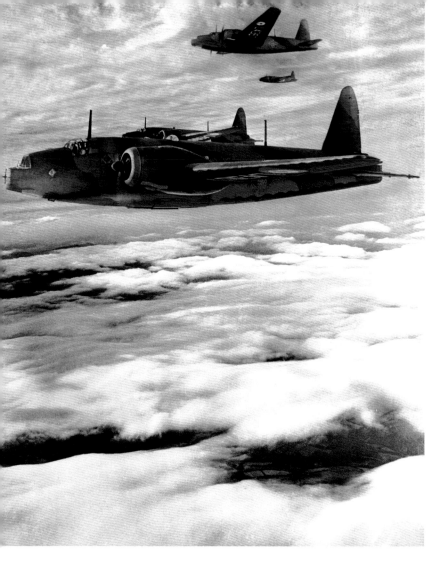

Facing page: A barrage balloon being prepared for launch. These balloons were used in large numbers during the Second World War to protect vulnerable targets from enemy air raids. They forced pilots to keep clear for fear of colliding with the mooring cables.
11th October, 1938

Vickers Wellington bombers flying in close formation among the clouds. The Wellington was a twin-engine medium bomber that had a unique fuselage construction devised by Barnes Wallis, creator of the 'bouncing' bomb. Wallis used a large number of thin aluminium sections to create a lattice framework of immense strength, which was covered with fabric. The Wellington was known affectionately as the 'Wimpy' after the character J. Wellington Wimpy in the Popeye cartoons.
10th August, 1938

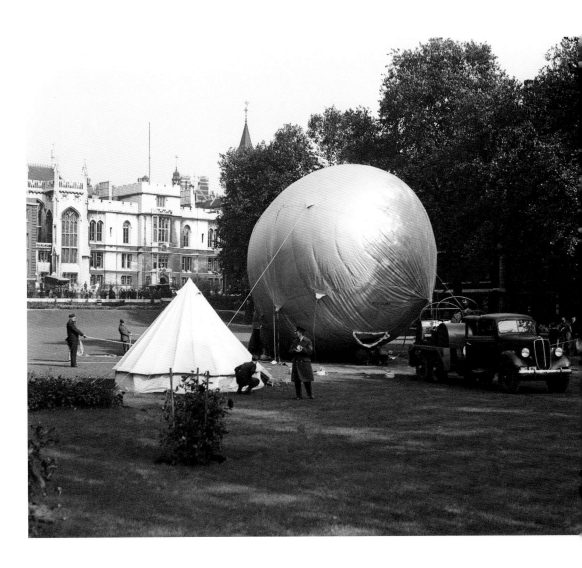

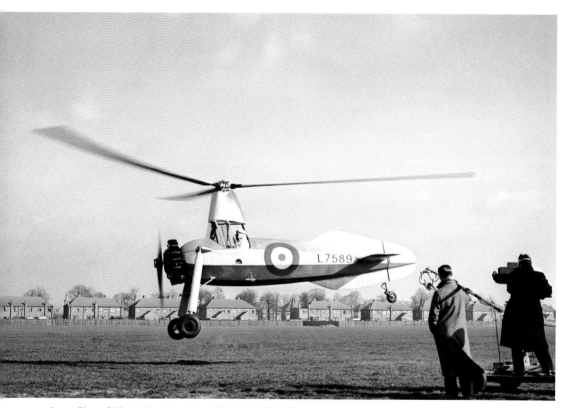

A new Cierva C40 autogiro being tested at the Royal Aircraft
Establishment, Odiham, Hampshire. Unlike earlier Cierva
autogiros, which required a short ground run to take off and
land, this machine could take off and land vertically like a
helicopter. It remained at the RAE until 29th April, 1940,
when it was written off while taking off.
10th January, 1939

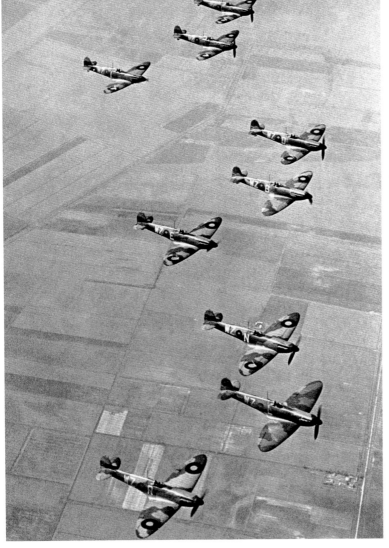

The Royal Air Force's No 19 Squadron, based at Duxford, Cambridgeshire, flying its new Supermarine Spitfire fighters. The squadron was the first to be equipped with the Spitfire, and these machines are very early Mk 1 examples, having two-blade fixed-pitch propellers. Later Mk 1s had three-blade variable-pitch propellers that provided improved performance.
1st May, 1939

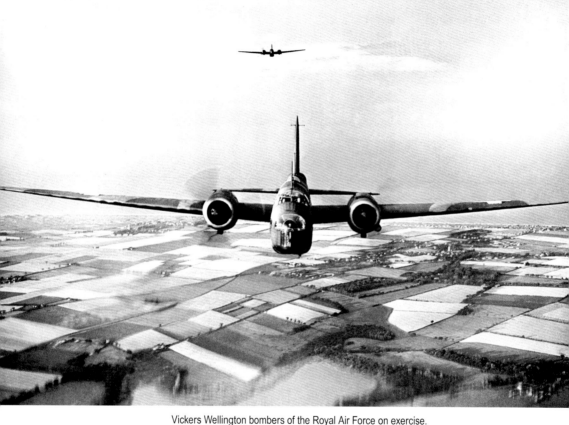

Vickers Wellington bombers of the Royal Air Force on exercise.
The Wellington was used extensively as a night bomber during
the early years of the Second World War until superseded
by heavier four-engine machines like the famous Lancaster.
Subsequently, many were used for anti-submarine duties.
1st May, 1939

Pauline Mary de Peauly Gower waves from the cockpit of a de Havilland Tiger Moth trainer. She was a British pilot and author who headed the women's branch of the Air Transport Auxiliary during the Second World War. The ATA's job was to ferry new aircraft from the factories to the RAF's airfields. Pauline Gower died in childbirth in 1947.

15th June, 1939

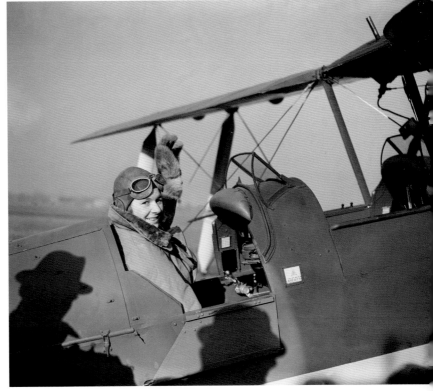

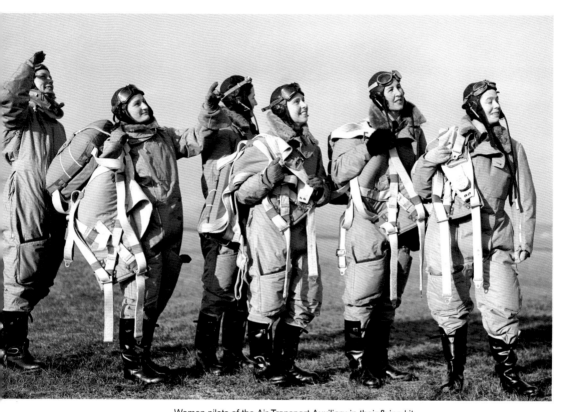

Women pilots of the Air Transport Auxiliary in their flying kit
ready to go to work. The women of the ATA ferried all manner of
aircraft during the Second World War, from the smallest training
aeroplanes to the heaviest of bombers. Usually they received
no conversion training on new machines, but simply were given
a handbook and told to get on with it.
15th June, 1939

Three of the first nine women pilots to join the Air Transport Auxiliary: Mrs Marion Wilberforce, Miss Rosemary Rees and Mrs G Patterson. All three women survived the war.
15th June, 1939

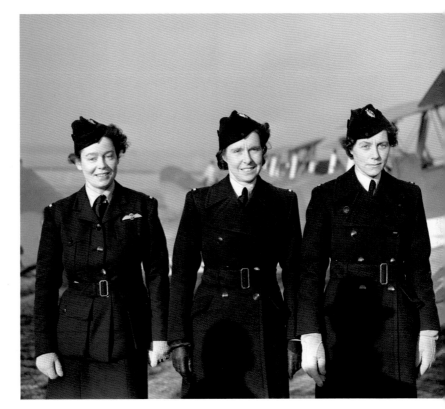

A de Havilland DH60GIII Moth Major climbs out from Broxbourne Aerodrome, Hertfordshire. In all, 154 of these machines were built before production switched to the Tiger Moth, the latter having swept back upper wings, which made it easier for the occupant of the front seat to get in and out of the aircraft, or abandon it in flight while wearing a parachute.
1st December, 1939

Public school cadets inspect Mk 1A Spitfires belonging to
the Royal Air Force's No 152 Squadron at RAF Acklington in
Northumberland. During the following year, the squadron's
machines would be busy defending southern England during
the Battle of Britain.
15th December, 1939

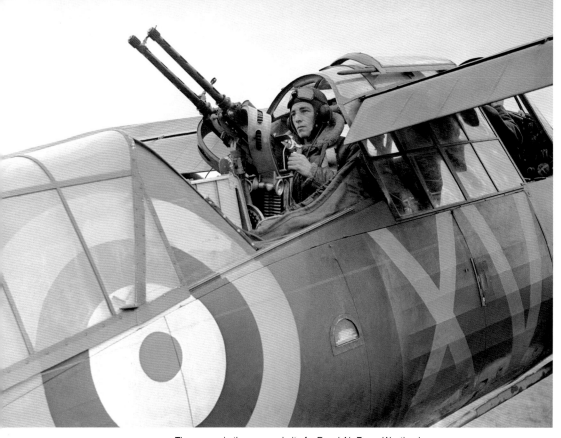

The gunner in the rear cockpit of a Royal Air Force Westland Lysander checks his machine guns prior to a sortie. The Lysander had been developed as an army co-operation and reconnaissance machine, and was renowned for its short-field performance. Specially adapted versions were used on clandestine missions to deliver and collect Allied agents in occupied France during the Second World War.
1940

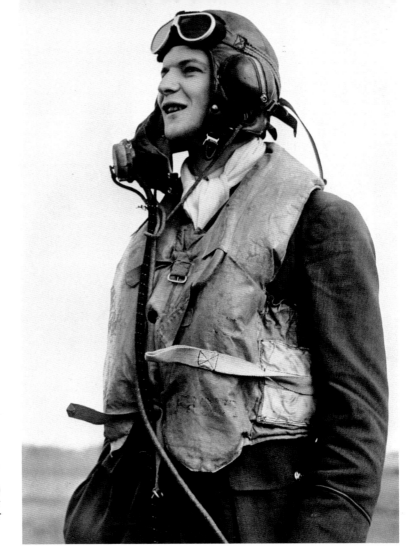

A typical Royal Air Force fighter pilot during the Battle of Britain. He wears a 'Mae West' life jacket over his uniform. Over 540 young men of RAF Fighter Command would lose their lives during the battle.

14th January, 1940

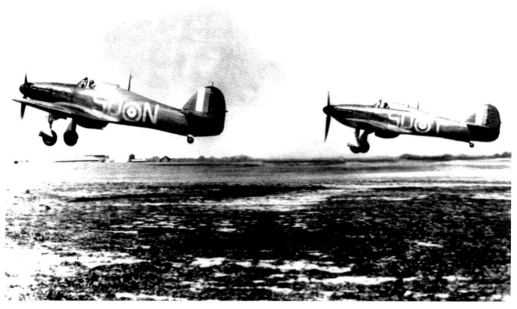

Two Hawker Hurricane Mk 1 fighters from No 79 Squadron take off from RAF Hawkinge in Kent during the Battle of Britain. The Hurricane was a single-seater designed and predominantly built by Hawker Aircraft. With the Supermarine Spitfire, it was the mainstay of the Royal Air Force's defence effort during 1940.

20th July, 1940

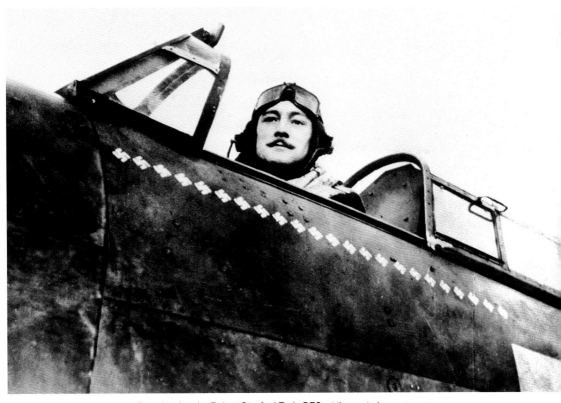

Squadron Leader Robert Stanford Tuck, DFC, at the controls of his Hawker Hurricane. Tuck had recently been promoted to head No 257 Squadron at RAF Coltishall, Norfolk in mid-September 1940. While flying the Hurricane, he destroyed at least seven enemy aircraft and probably another four.

September 1940

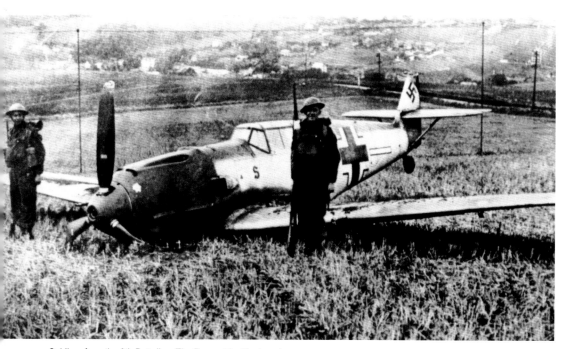

Soldiers from the 9th Battalion, The Devonshire Regiment, guard a Messerschmitt Bf109E of the German Air Force, which had crash-landed near Beachy Head, East Sussex following a dogfight with Royal Air Force fighters during the Battle of Britain. The 109 was equipped with a cannon that fired through the centre of the propeller hub.

30th September, 1940

Facing page: For sixpence, the public is given a chance to inspect a German Air Force Messerschmitt BF110 twin-engine machine belonging to a precision fighter-bomber unit. It had been brought down by anti-aircraft fire during an attack on RAF Hawkinge, near Folkestone in Kent. The aircraft was eventually shipped to the Vultee Aircraft Corporation in the USA for testing and evaluation.

15th October, 1940

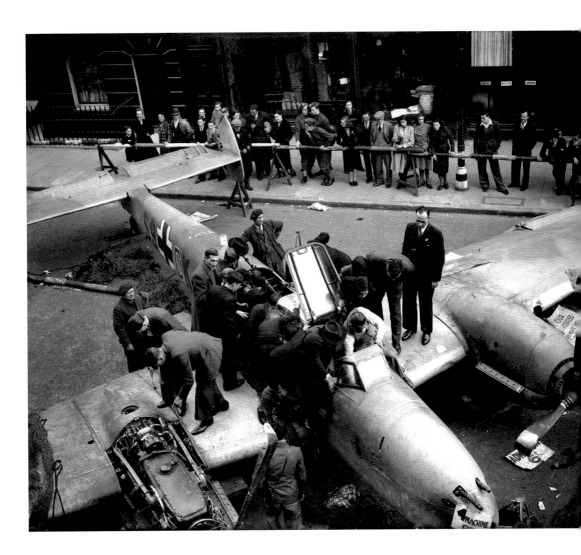

Prince Bernhard of the Netherlands about to embark on a training flight in Britain during the Second World War. He qualified as a pilot in 1941 and was made an honorary wing commander in the Royal Air Force, going on to fly Spitfires with the RAF's 322 'Dutch' Squadron, during which time he wrecked two aircraft. To protect his identity, he was known as Wing Commander Gibbs.
1941

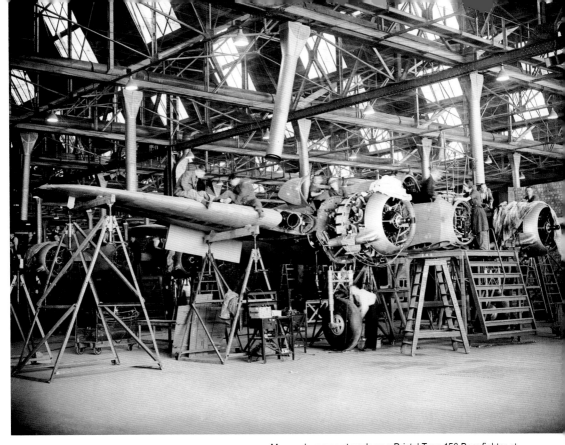

Men and women at work on a Bristol Type 156 Beaufighter at the Bristol Aeroplane Company works at Filton, near Bristol. The twin-engine machine, which carried a crew of two, filled a number of roles during the Second World War, including night fighter, fighter-bomber and torpedo-bomber.

5th August, 1941

An RAF fighter pilot in full flying kit. His parachute is designed to fit into a recess in the base of his aircraft's seat, much like a cushion, and he would sit on this throughout the period of his mission. Unlike a cushion, however, it was not very comfortable.

28th August, 1941

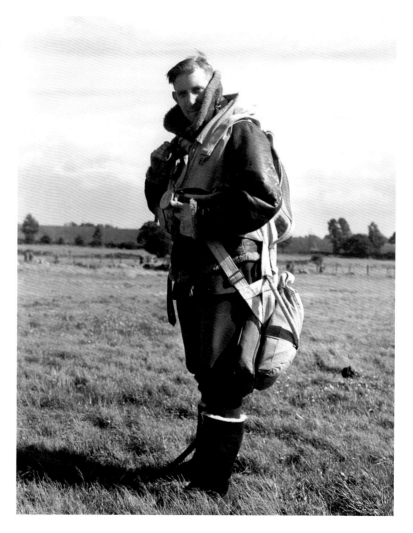

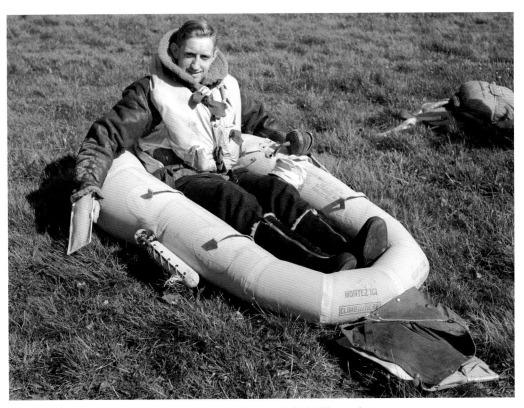

Also part of the pilot's equipment attached to his parachute harness was this small inflatable dinghy for use in case of a crash landing at sea. It was supplied with small paddles that could be worn on the hands. Surprisingly, such tiny craft saved a number of pilots' lives.

28th August, 1941

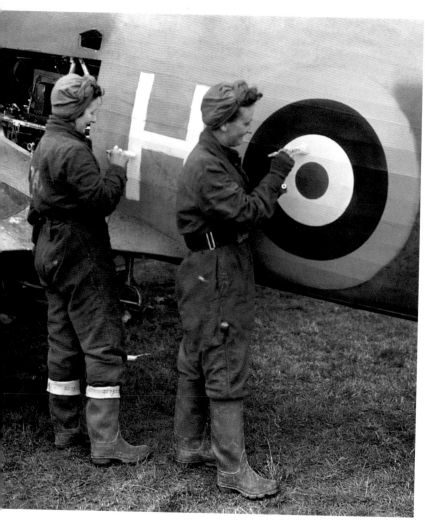

Two flight mechanics belonging to the Women's Auxiliary Air Force (WAAF) paint squadron markings on the fuselage of a Hawker Hurricane. Although not permitted to fly RAF aircraft or take any combat role, Waafs, as they were known, performed a number of vital duties during the Second World War.

13th December, 1941

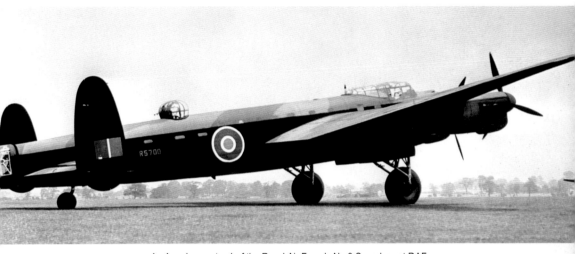

An Avro Lancaster 1 of the Royal Air Force's No 9 Squadron at RAF Waddington in early 1942. This particular machine, serial number R5700, was reported missing over Hanover, Germany on 23rd September, 1943. It had been shot down and had crashed at Bad Munder-am-Deister, to the southwest of the city. None of the crew survived. They were buried in the local war cemetery. The Lancaster was the most successful of the RAF's four-engine heavy bombers.
1942

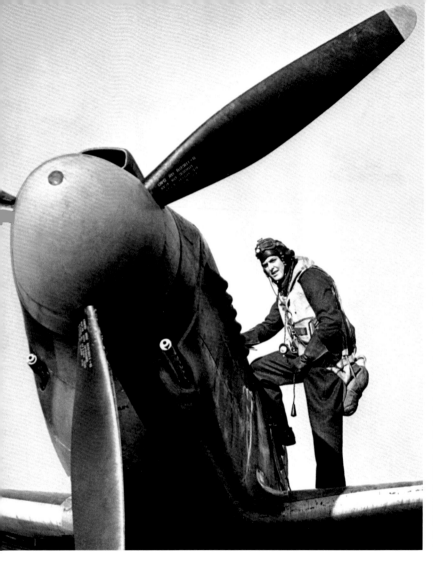

An RAF pilot climbs into the cockpit of a North American Mk 1A Mustang. This remarkable aircraft was designed, built and flying in 117 days. Built in America, it had been conceived at the request of the British, and served with the RAF as a fighter-bomber and reconnaissance machine. Equipped with an Allison V12 engine initially, subsequently it was fitted with the renowned Rolls-Royce Merlin, as used in the Spitfire, Hurricane and Lancaster, and went on to become a superb long-range fighter capable of escorting bomber formations all the way to Berlin in Germany. **1942**

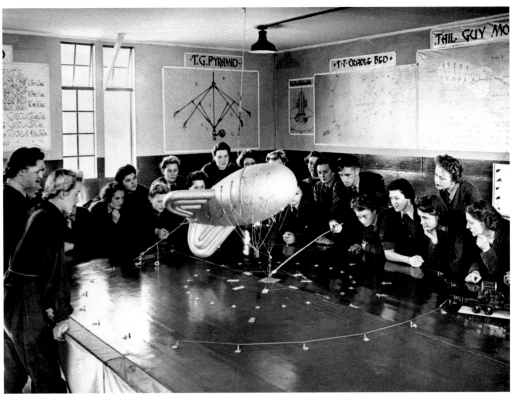

A Royal Air Force corporal instructs a group of Waafs on the techniques used for mooring a barrage balloon. Practically all balloon sites in Britain were operated by women, freeing men for more vital duties. The balloons were intended to protect vulnerable targets from low-level bombing attacks. They forced aircraft to fly higher, where they could be engaged by anti-aircraft fire.
1942

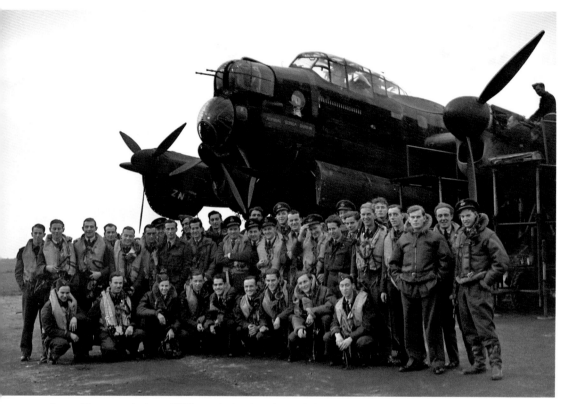

Some of the crews of a force of 88 Lancaster bombers that carried out a surprise daylight attack on the city of Milan in Italy on 24th October, 1942. The raid, which required a 1,500-mile round flight over the Alps, was one of a series of attacks that were carried out in support of a British offensive at El Alamein in Egypt and Anglo-American landings elsewhere in North Africa. The raids also helped turn the Italian people against their leader, Mussolini.
26th October, 1942

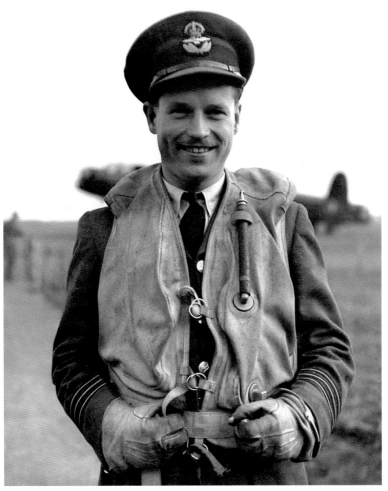

Wing Commander Guy Gibson, DFC and bar, aged 24, who led the Lancaster force that carried out the daylight attack on Milan in October 1942. Seven months later, Gibson would lead Lancasters of the specially formed 617 Squadron in an attack against the dams of the Eder and Ruhr valleys in Germany, using 'bouncing' bombs developed by Vickers designer Barnes Wallis. This resulted in the destruction of the Möhne and Eder dams. Subsequently, 617 Squadron adopted the motto, 'Après moi, le déluge' (After me, the flood).

26th October, 1942

The Hawker Typhoon was intended to replace the Hawker Hurricane as a mid- to high-level interceptor, but it was not completely successful in that role. However, the Royal Air Force soon found that it made an outstanding ground-attack aircraft, not only being equipped with four cannon, but also capable of carrying bombs or rockets. This example is painted with black and white 'invasion stripes' to identify it during the D-Day landings.

June, 1944

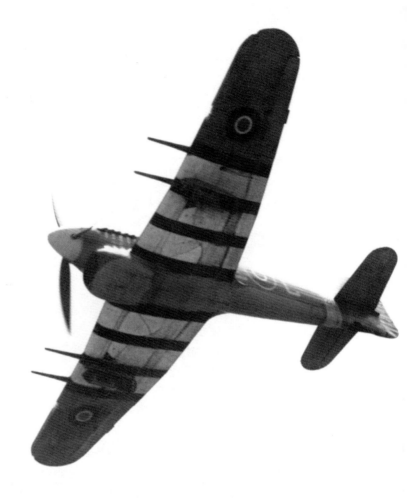

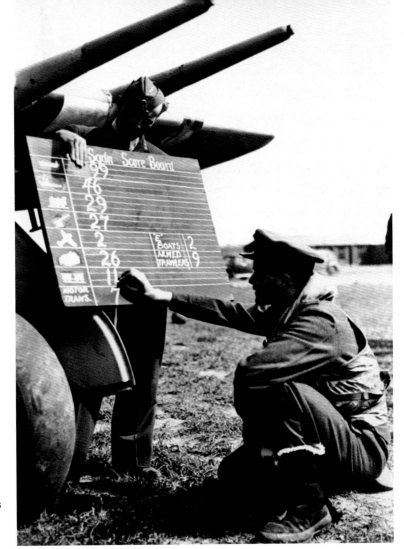

A Royal Air Force Hawker Typhoon pilot chalks up the squadron's score during the D-Day operation, the invasion of Normandy by the Allies. The Typhoon was affectionately known as the 'Tiffy' by its pilots.
6th June, 1944

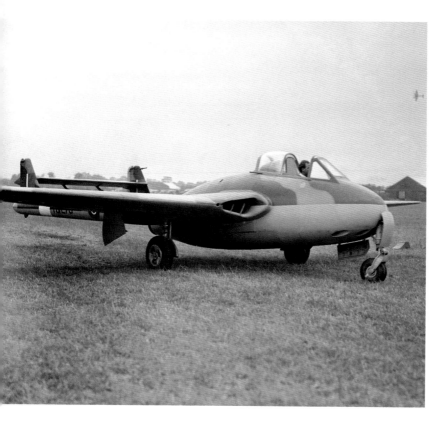

A British de Havilland Vampire DH 100 jet fighter. The machine was the second jet aircraft ordered by the Royal Air Force, but it was developed too late to see action during the Second World War. It served with front-line RAF squadrons until 1955, however, and continued as a trainer until 1966.
1st October, 1945

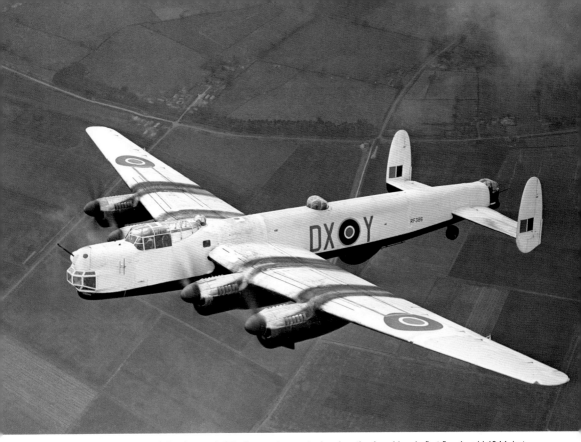

A development of the famous Lancaster bomber, the Avro Lincoln first flew in mid-1944, but it reached squadrons too late to take part in the Second World War. However, it was involved in British police actions in Africa and Malaya. It was the Royal Air Force's last piston-engine bomber. This example belonged to 57 Squadron, based at East Kirby in Lincolnshire.
1st October, 1945

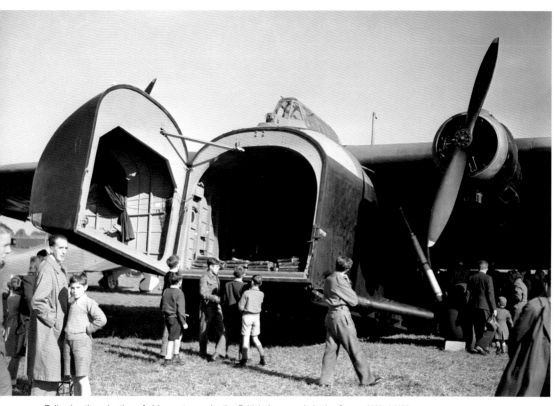

Following the adoption of airborne troops by the British Army early in the Second World War, it was decided that a large glider would be needed to deliver their heavy equipment and small vehicles. For this purpose, the General Aircraft company developed the Hamilcar glider, which saw action during the D-Day landings and Operation Market Garden, when airborne forces attempted to seize the Rhine bridges. A powered version, the Mk X, seen here, was conceived to improve the machine's range and allow it to be employed in the Pacific, but the war ended before it could be used.

1st November, 1945

The Miles M57 Aerovan was a British short-range low-cost transport aircraft designed and built by Miles Aircraft. It could be configured internally to carry either passengers or freight, its rear clamshell doors making it possible to load even a family-sized car. Production ended in 1947 after 52 examples had been built.

5th February, 1946

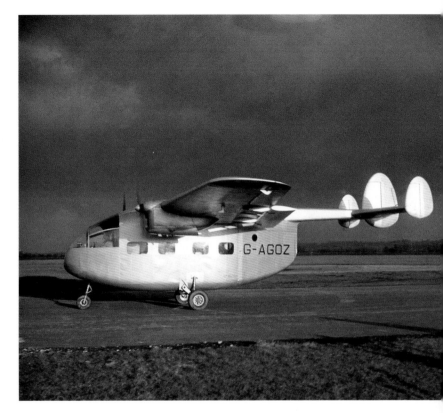

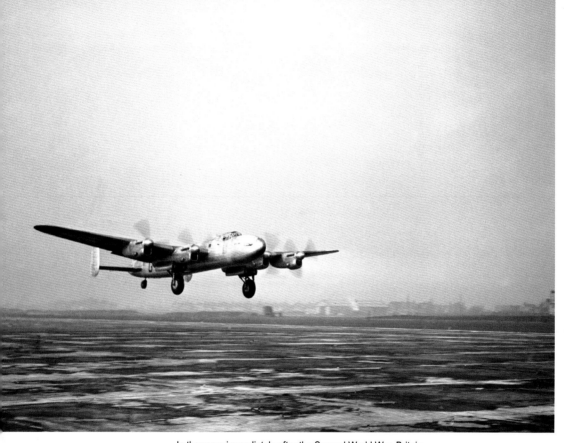

In the years immediately after the Second World War, Britain had an urgent need for long-range civil airliners. As a result, many former heavy bombers were converted to civilian use. The Avro 691 Lancastrian was just such a conversion. This example, named *Star Light*, belonged to British South American Airways, which operated 18 of the machines. Each was capable of carrying 13 passengers.
1946

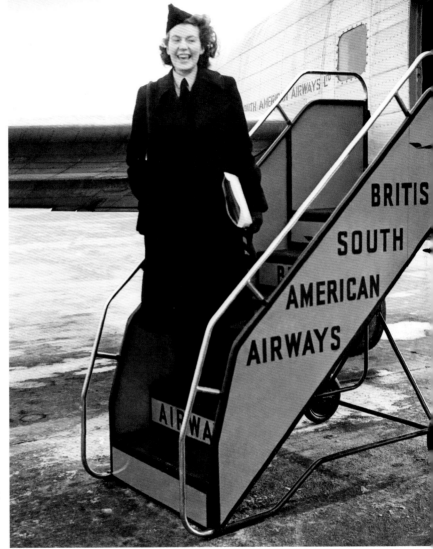

Mary Guthrie, a hostess on board British South American Airways' Lancastrian *Star Light*. The machine would make the first international departure from the newly opened Heathrow Airport in Middlesex.
24th March, 1946

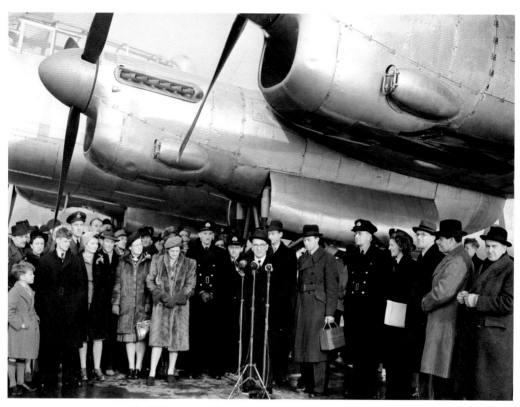

Lord Winster, speaking at the opening of Heathrow as a civil airport. Around him stand the passengers and crew of the Lancastrian airliner *Star Light*, while the massive engines of the machine loom above.

25th March, 1946

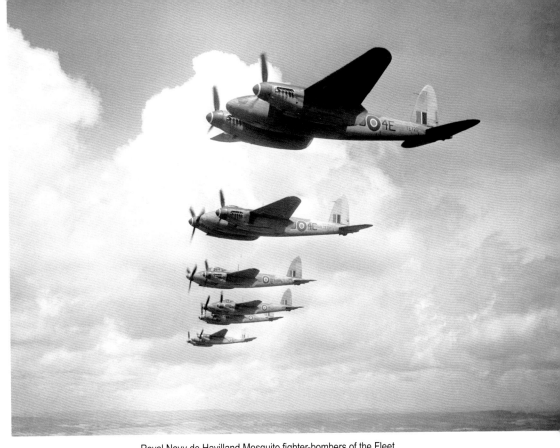

Royal Navy de Havilland Mosquito fighter-bombers of the Fleet Air Arm's 811 Squadron flying in formation. The squadron had been equipped with the aircraft in September 1945. The Mosquito had been conceived originally as a fast unarmed bomber, but subsequently was adopted for a number of other roles. It was made from moulded plywood, which was unusual at a time when most military aircraft were all metal.

1st May, 1946

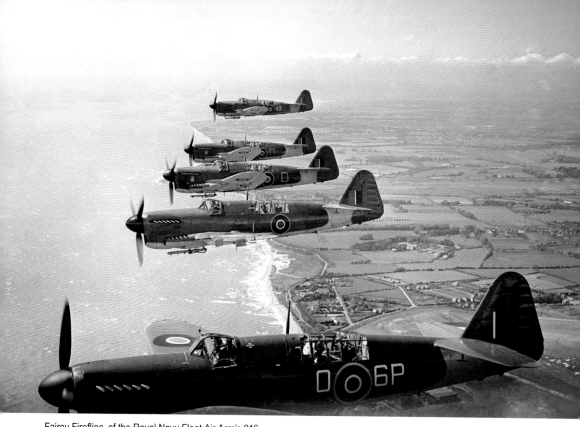

Fairey Fireflies, of the Royal Navy Fleet Air Arm's 816
Squadron, flying in formation as part of the celebrations
commemorating victory in the Second World War. The Firefly
was a carrier-borne fighter with a crew of two, a navigator
being considered essential when operating over the vast
wastes of the ocean.

1st June, 1946

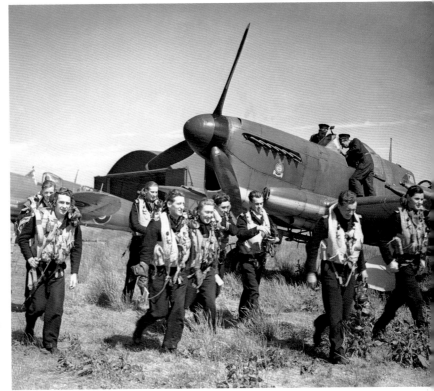

Having returned from a sortie, Fleet Air Arm Firefly pilots leave their machines in the hands of the mechanics who will check them over and prepare them for their next mission.
1st June, 1946

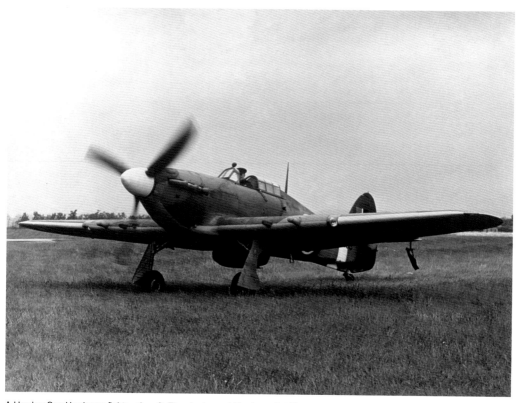

A Hawker Sea Hurricane fighter aircraft. The single-seat Hurricane had borne the brunt of the fighting during the Battle of Britain, and subsequently a version was developed for use on aircraft carriers so that it could protect ships from air attack during the Second World War. Early Sea Hurricanes were designed to be catapulted from the decks of merchant ships; when their fuel ran out, their pilots were required to bale out, as they could not be landed back on the ships.

8th June, 1946

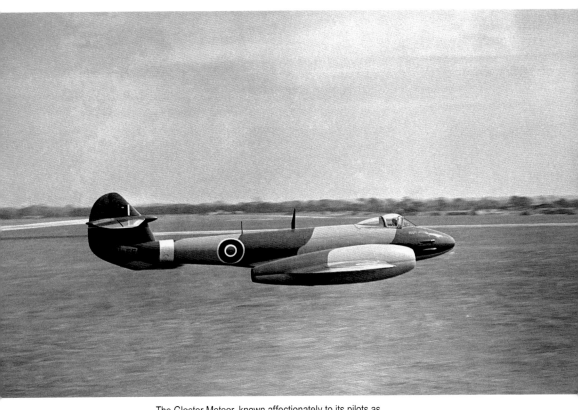

The Gloster Meteor, known affectionately to its pilots as the 'Meatbox', was the first jet fighter to be commissioned by the Royal Air Force, and it saw action toward the end of the Second World War; it was the Allies' first operational jet. This example is a Mk 3, and it was converted in 1947 into a Meteor T7 two-seat trainer.

4th July, 1946

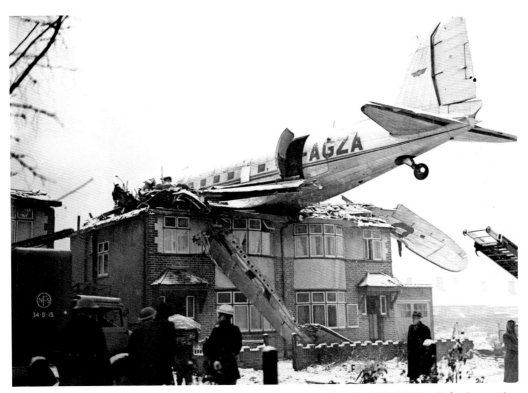

Facing page: A pilot looks down from the cockpit of a Handley Page Halifax bomber, which has a modified nose cone containing radar equipment. The Halifax was a four-engine heavy bomber and a contemporary of the Avro Lancaster. It equipped many squadrons of Royal Air Force Bomber Command during the Second World War.
16th November, 1946

Hitting the roof. A Douglas DC3 of Railway Air Services perches precariously on top of a house in the London suburb of Northolt, Middlesex after crashing onto the roof. The machine had just taken off from RAF Northolt, where the aircraft's captain, William Johnson, subsequently known as 'Rooftops', had supervised its de-icing prior to take-off. Fresh snowfall on the wings destroyed their lift, however, preventing it from climbing away. The crew of four and one passenger escaped unhurt.
19th December, 1946

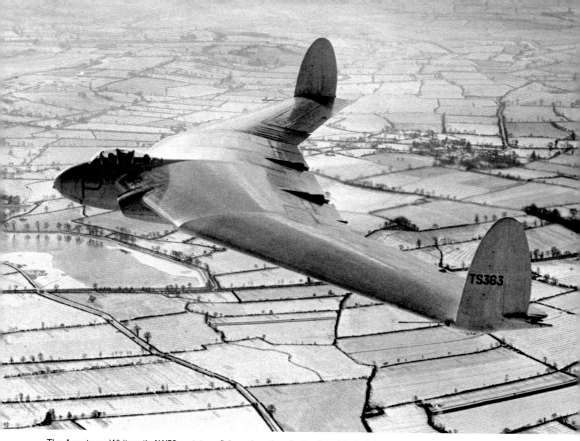

The Armstrong Whitworth AW52 prototype flying-wing aircraft, developed to test the concept of a four- or six-engine jet-powered airliner, in which the passengers would sit within the wing. Two prototypes were built, this example being equipped with two Rolls-Royce Nene jet engines. The results of the trials were disappointing, however, and further work was abandoned. This aircraft crashed in 1949, its pilot escaping by means of an ejector seat, the first time such a device was used in a true emergency.
1947

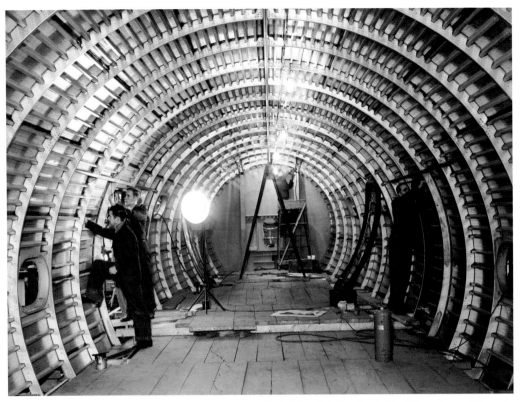

Technicians installing the electrical fittings in one of the main decks of the massive Bristol Type 167 Brabazon, which, at the time, was the largest land aircraft in the world. Despite its size and power, and unrivalled passenger comfort, only one prototype was ever flown, the airlines considering it too large to operate successfully. It was broken up for scrap in 1953.
6th January, 1947

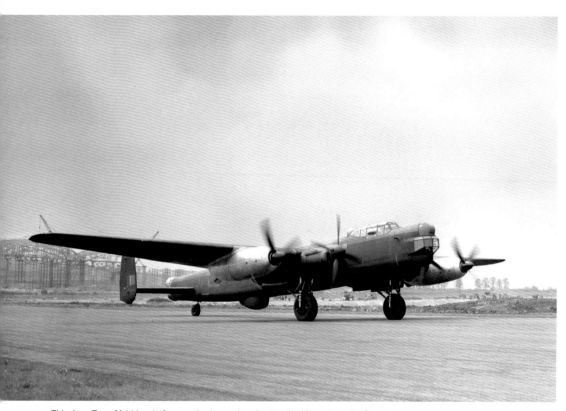

This Avro Type 694 Lincoln four-engine heavy bomber has had its outer pair of engines replaced by two Theseus gas-turbine engines, allowing them to be tested under flight conditions. The Theseus was the Bristol Aeroplane Company's first attempt at developing such a power unit and provided valuable data for the development of the later and more powerful Proteus.

22nd April, 1947

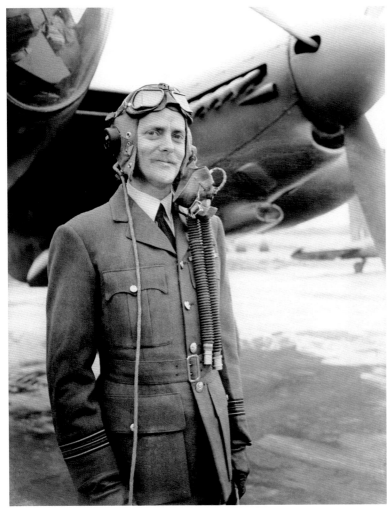

Squadron Leader H.B. 'Micky' Martin stands in front of the RAF de Havilland Mosquito in which he would break the London-to-Cape Town speed record between 30th April and 1st May, 1947. He and Squadron Leader E.B. Sismore covered the 6,717 miles in 21 hours, 31 minutes at an average speed of 279mph. Martin was the only surviving pilot of those who had attacked the Möhne Dam during the famous 'Dambusters' Raid of the Second World War.

30th April, 1947

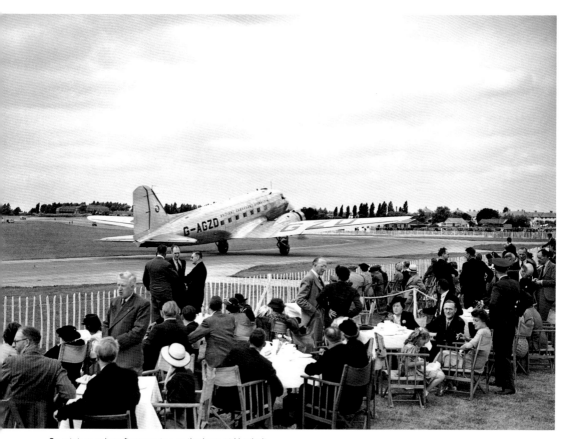

Spectators enjoy afternoon tea on the lawn at Northolt Airport as a British European Airways (BEA) Douglas DC3 taxis past. Fortunately, they are seated far enough away from the machine to be clear of its propwash, which would have wreaked havoc with the sticky buns.

28th July, 1947

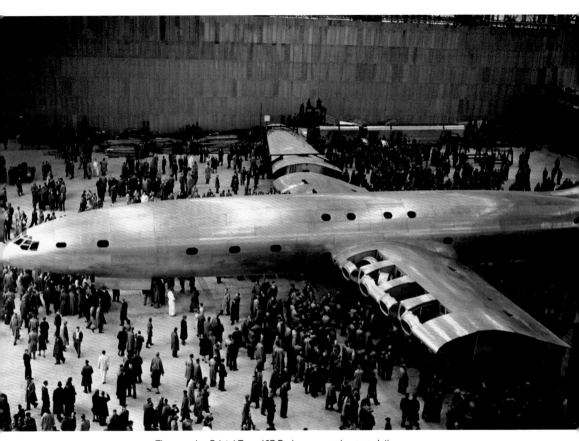

The massive Bristol Type 167 Brabazon, nearing completion in its hangar, is shown to the public. The machine first flew in September 1949, but it could only carry 100 passengers and was deemed uneconomic by the airlines of the day.

27th September, 1947

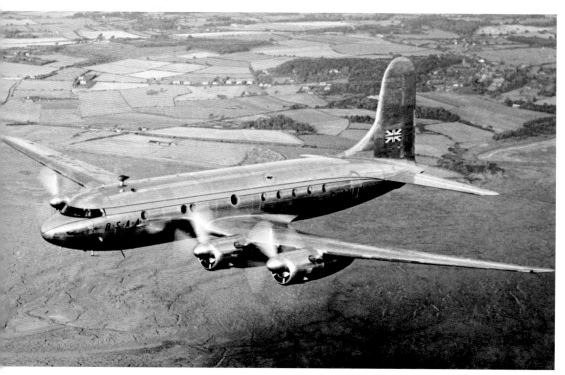

An Avro Tudor, *Star Lion*, of British South American Airways. The machine had been developed from the Lincoln four-engine bomber and was Britain's first pressurised airliner. It saw only limited success, however, since most airlines preferred to purchase more reliable American aircraft.
4th October, 1947

Facing page: A mock-up of the hull of the Saunders-Roe SR45 Princess flying boat being built at Cowes on the Isle of Wight. At the time, the aircraft was one of the largest in existence. The machine had been planned originally for use on transatlantic routes, but by the 1950s flying boats were being sidelined by long-range land-based aircraft and improved airport facilities. Although three Princesses were built, only one flew. They were mothballed awaiting possible future use, but eventually were broken up in 1967.
14th January, 1948

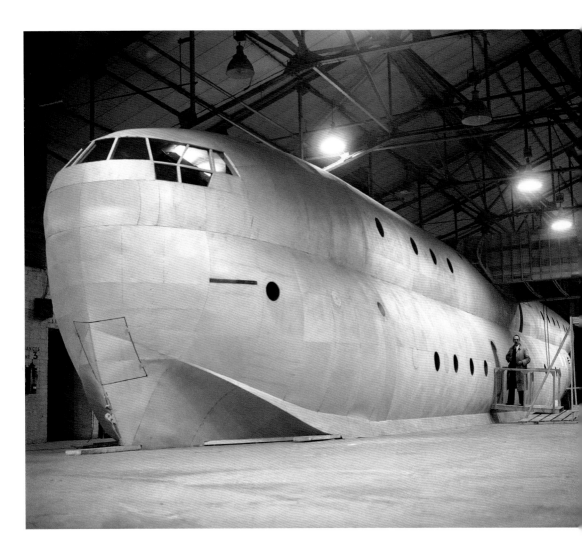

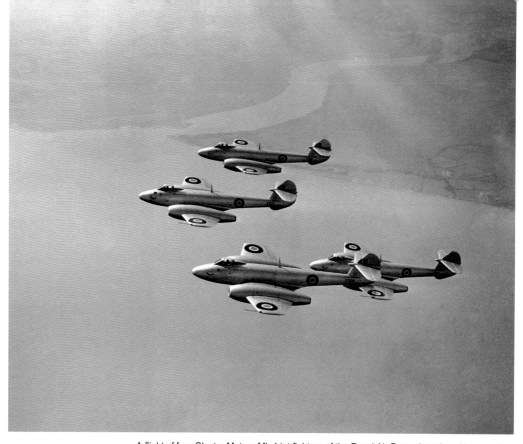

A flight of four Gloster Meteor Mk 4 jet fighters of the Royal Air Force. Introduced into service in July 1944, the Meteor remained in production until 1954. After retirement from front-line service, it soldiered on in many support roles, notably as a target tug, from which duty it was retired by the RAF in the 1980s. In 2009, two Meteors were still being used as flying test-beds by the Martin-Baker ejection seat manufacturer.

28th April, 1948

A Boulton Paul Sea Balliol
T21 trainer with wings
folded. This machine was
a version of the standard
Balliol land-based trainer
and had been developed
to allow trainee naval pilots
to practise deck landings.
Sea Balliols remained in
service with the Fleet Air
Arm until 1963.
28th June, 1948

An Avro Shackleton undergoing testing in 1949. Named after the famous Antarctic explorer, Sir Ernest Shackleton, the machine entered service in 1951 and was used by the Royal Air Force as a long-range maritime patrol aircraft. It had been developed from the Lincoln heavy bomber. The RAF continued to use Shackletons in the airborne early warning role until 1990.
19th April, 1949

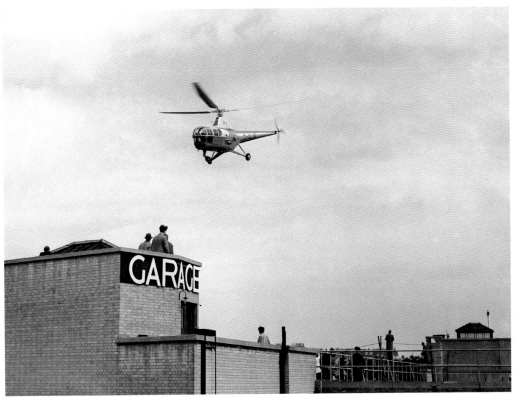

A Westland WS-51 Dragonfly helicopter takes off from Olympia in London on the first helicopter passenger flight to Paris. The Dragonfly was a licence-built version of the American Sikorsky S-51. It was used by the Royal Navy for search and rescue work.

5th May, 1949

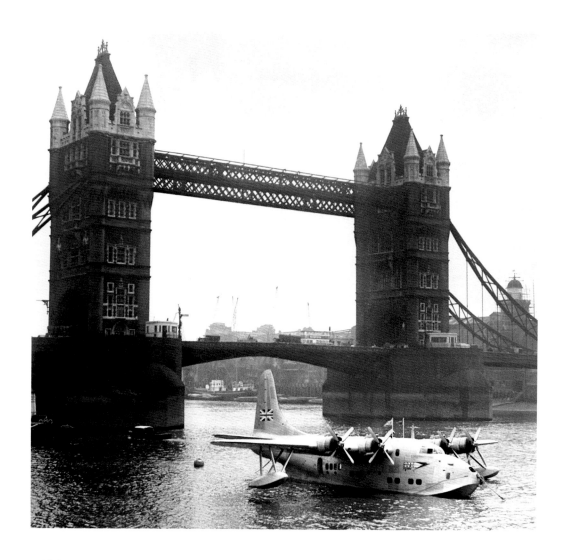

Facing page: A Short Solent flying boat belonging to BOAC on display on the Thames in London and moored close to Tower Bridge. The aircraft, named *City of London*, was there to be christened by Sir George Aylwen, the Lord Mayor of London, on 10th May, 1949. The Solent was built between 1946 and 1949, and BOAC flew their machines between Southampton and Johannesburg, South Africa, the journey taking four days.
5th May, 1949

Miss Roy Mary Sharpe, a former pilot with the Air Transport Auxiliary, was the only woman to enter the cross-country King's Cup Air Race in 1949, flying a single-engine Miles M28 Mercury. That year's race was the first since 1938, the annual contest having been interrupted by the Second World War. It was won by J. Nat Somers in another Miles aircraft, a Gemini twin.
20th July, 1949

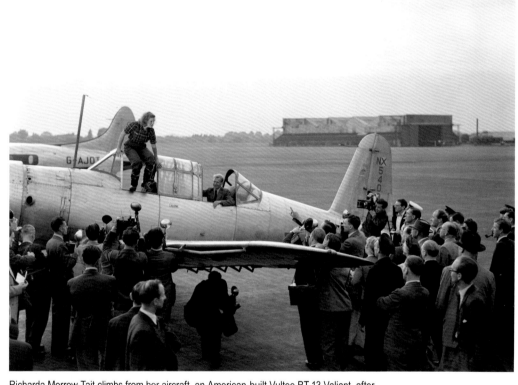

Richarda Morrow-Tait climbs from her aircraft, an American-built Vultee BT-13 Valiant, after arriving at Croydon Aerodrome to complete a 25,000-mile round-the-world flight, making her the first woman to do so. Her navigator, Jack Ellis, is in the rear cockpit. Richarda had begun the endeavour in a British-built Percival Proctor, but after many adventures this had been damaged beyond repair in Alaska. To complete her flight, she had purchased the new machine in America.

19th August, 1949

A year and a day after she had set out on her round-the-world flight, Richarda Morrow-Tait returns joyfully to Croydon Aerodrome. Surprisingly, she received little acclaim for her feat, and was even criticised by some for abandoning her motherly duties.

19th August, 1949

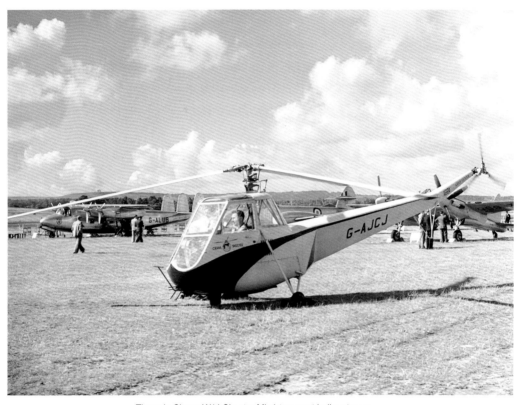

The sole Cierva W14 Skeeter Mk 1 two-seat helicopter on display at the Farnborough air show. The machine was the first of the Skeeter series, all of which were underpowered until the Mk 7, built by Saunders-Roe, which had a 215hp de Havilland Gipsy engine. The British Army bought 64 of these machines for air observation duties.
3rd September, 1949

An English Electric Canberra B1 in flight. The Canberra was one of the Royal Air Force's first-generation jet bombers, and it proved to be highly adaptable to a number of roles, including photographic, electronic and meteorological reconnaissance. Examples were operated by the RAF until 2006. The United States manufacturer Martin also built a large number under licence for the US Air Force.

5th September, 1949

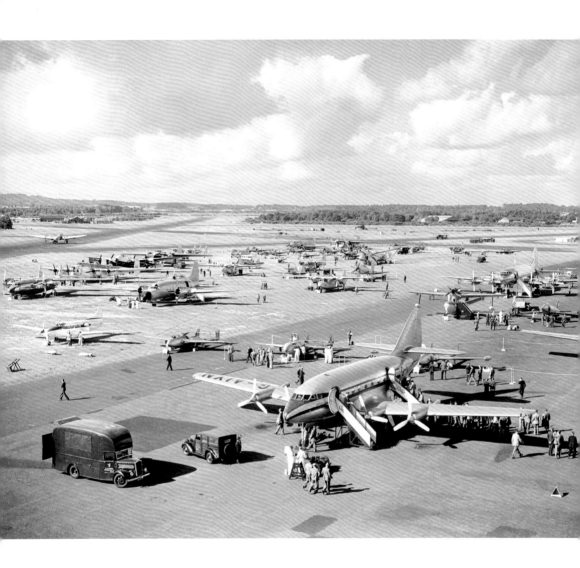

Facing page: Aircraft lined up for display during the annual Farnborough air show of 1949. The show had moved to the Hampshire airfield in 1948 and was a showcase for British aviation manufacturers.

5th September, 1949

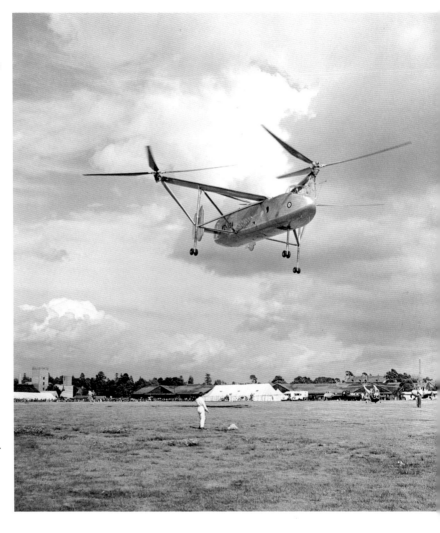

The Cierva Air Horse 24-seat helicopter is displayed during the Farnborough air show. This was the largest helicopter in the world when it first flew in 1948. A development of the German Focke-Wulf FW 61, it was the only helicopter of its type ever built and had three rotors driven by a Rolls-Royce Merlin engine. The machine crashed in 1950, killing the crew, and further development was abandoned.

5th September, 1949

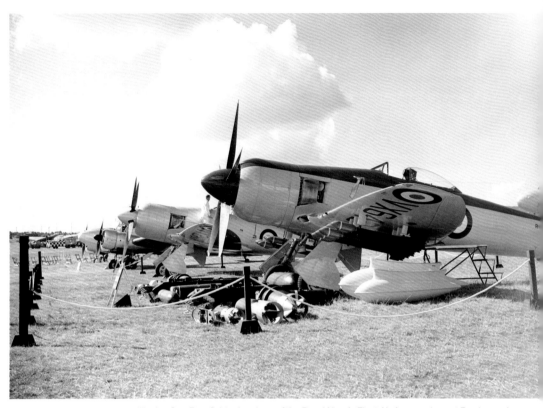

Hawker Sea Fury fighter-bombers of the Royal Navy's Fleet Air Arm on show at Farnborough. The Sea Fury was a development of the highly successful Typhoon and Tempest fighters of the Second World War. It arrived too late to participate in that conflict, but saw a considerable amount of action during the Korean War. It was the Royal Navy's last piston-engine fighter and one of the fastest ever single-piston-engine aircraft ever built.

5th September, 1949

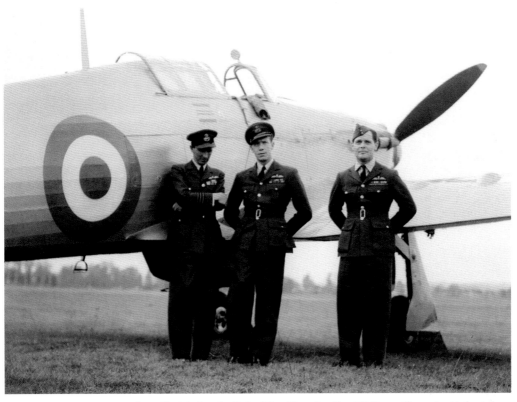

Group Captain Douglas Bader (R) and two other Royal Air Force officers stand in front of a Hawker Hurricane, one of the machines that Bader flew during the Second World War. Despite having lost both legs in a flying accident in 1931, he proved that he could fly just as well without them and served as a fighter pilot during the conflict, downing 22 enemy machines. He was shot down in August 1941 and held prisoner by the Germans until liberated in 1945.

18th September, 1949

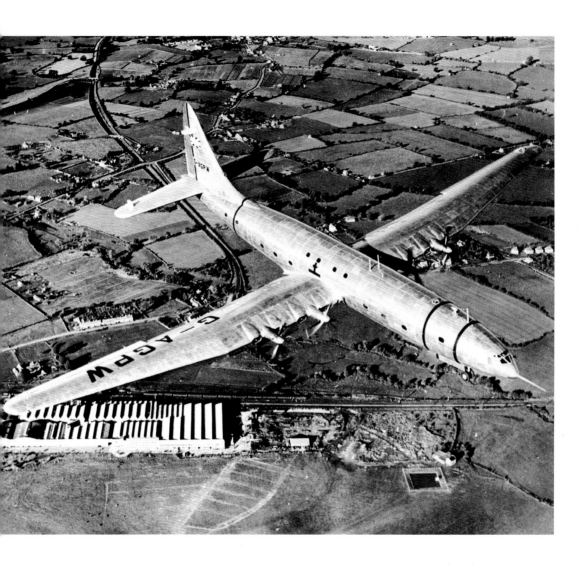

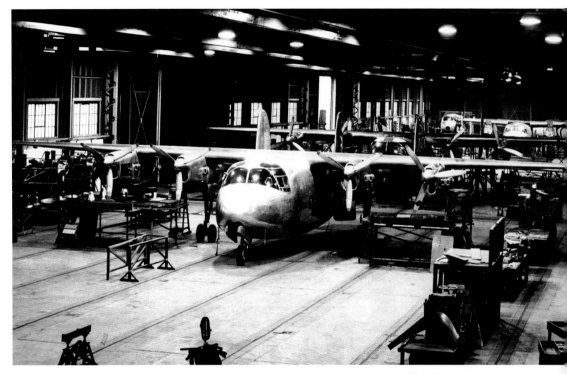

A Handley Page (Reading) HPR1 Marathon on the production line at the company's Radlett factory in Hertfordshire. The machine had been designed originally by Miles Aircraft, but the company ran into financial difficulties and was taken over by Handley Page. The Marathon could carry 20 passengers and two crew. Few examples sold to civil operators, however, and most were taken on charge by the Royal Air Force for use as navigation trainers. They were retired in 1958.

9th January, 1950

Facing page: Flying elephant. The prototype Bristol Type 167 Brabazon during a test flight. The huge machine was shunned by the airlines as a 'white elephant' and only the prototype ever flew.

31st October, 1949

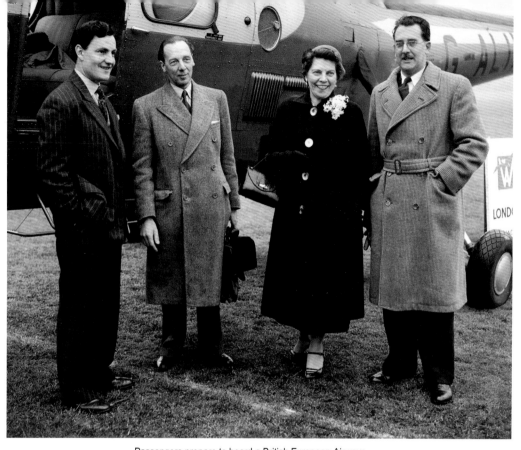

Passengers prepare to board a British European Airways Westland WS-51 for the world's first scheduled helicopter passenger service, from London to Birmingham. The flight would depart from the Harrods Sports Ground in Barnes, west London. L–R: Kenneth Reid (pilot), Mr Dyer, Nancy Craig and Courtney Edwards (*Daily Mail* aviation correspondent).
5th May, 1950

Captain Ian Harvey, DFC, pilot of a British European Airways Viking airliner that landed safely at Northolt Airport after an explosion had caused serious damage. For his action in saving the aircraft, he was awarded the George Medal. The aircraft had been over the middle of the English Channel on its way to Paris on 13th April, 1950 when the explosion occurred. The subsequent investigation confirmed that it had been caused by a bomb in the aircraft's toilet, but the culprit and reason were never discovered.

16th May, 1950

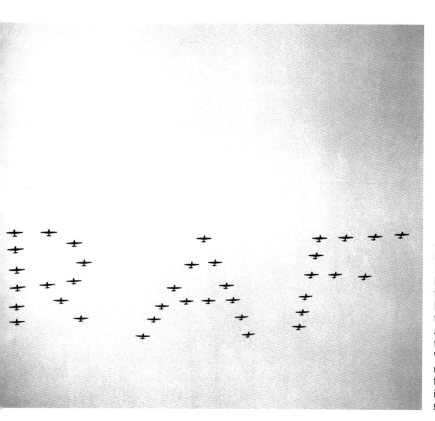

Sky writing. North American Harvard trainers of the Royal Air Force form the letters 'RAF' in flight during the Farnborough air show. Built in the United States, the Harvard was a popular advanced trainer that dated from the Second World War. It was used by a large number of air forces around the world, and many remain in civilian hands.
5th July, 1950

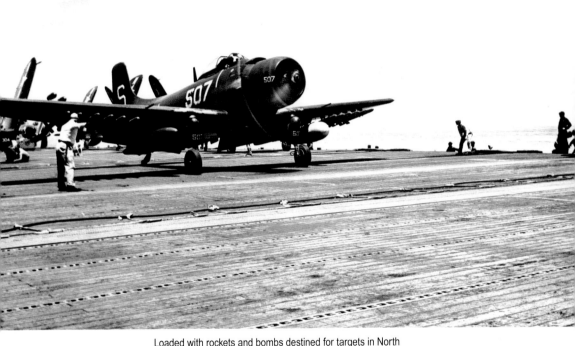

Loaded with rockets and bombs destined for targets in North Korea, this Douglas AD Skyraider is about to take off from a United States Navy carrier, which was part of a combined American-British task force. The Skyraider was a powerful and adaptable machine that specialised in close air support for ground troops. It also saw service in Vietnam during the late 1960s and 1970s.

10th July, 1950

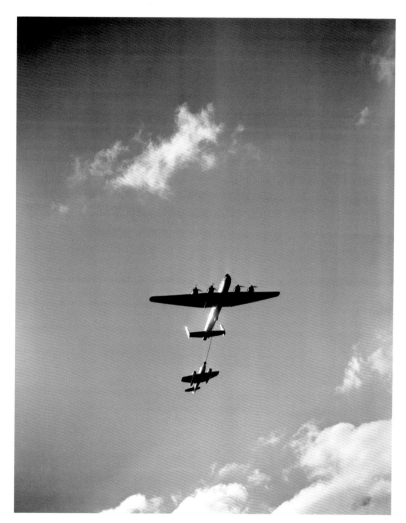

Fill 'er up. Experiments in air-to-air refuelling had been carried out in the early 1920s, and pioneering aviator Sir Alan Cobham had been involved in the development of some of the equipment required. Here a converted Avro Lincoln bomber tops up a Gloster Meteor in flight.

4th September, 1950

Back to work. A fully recovered British European Airways stewardess Susan Cramsie, 26, waves from the door of a BEA machine at Northolt Airport. She had been badly injured earlier in the year when a bomb had exploded aboard a Paris-bound Viking airliner flown by Captain Ian Harvey. Thanks to Harvey's flying skills, the aircraft returned safely to Northolt.

17th November, 1950

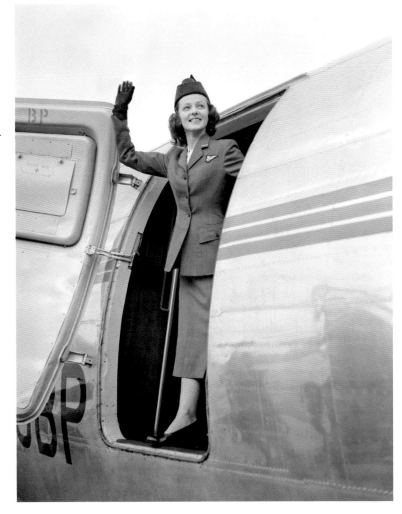

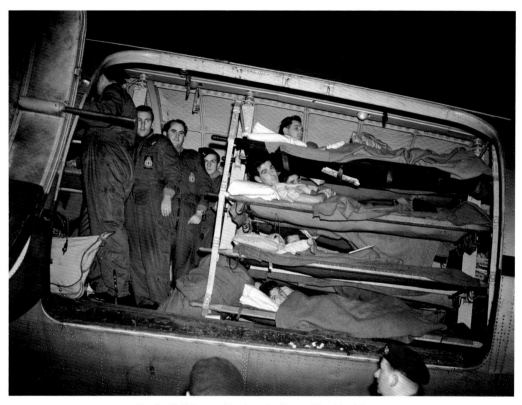

The first British casualties from the Korean War, 12 soldiers, arrive at Royal Air Force Station Lyneham, Wiltshire aboard a Handley Page HP67 Hastings of RAF Transport Command. With them in the aircraft is a two-year-old boy suffering from poliomyelitis, Peter Mounsey (second from bottom), the son of the medical officer at RAF Changi, Singapore.
22nd November, 1950

The sleek shape of an English Electric Canberra twin-jet
bomber of the Royal Air Force. Throughout the 1950s,
the Canberra could fly higher than any other bomber.
On 28th August, 1957, a rocket-assisted version set an
altitude record of 70,310ft.
18th February, 1951

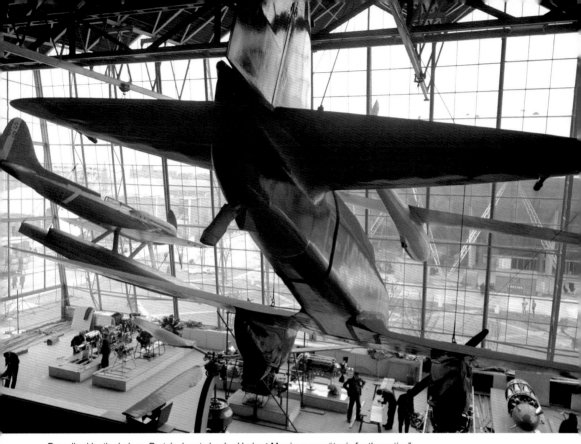

Described by the Labour Party's deputy leader Herbert Morrison as a "*tonic for the nation*", the Festival of Britain was a series of exhibitions aimed at giving the population a sense of pride, and a feeling of recovery and progress after the grim wartime years of the 1940s. This Transport Pavilion was at the main site on London's South Bank. Hanging from the roof are two prewar racing aircraft, a Supermarine S6 seaplane (L) and a de Havilland Comet.
16th April, 1951

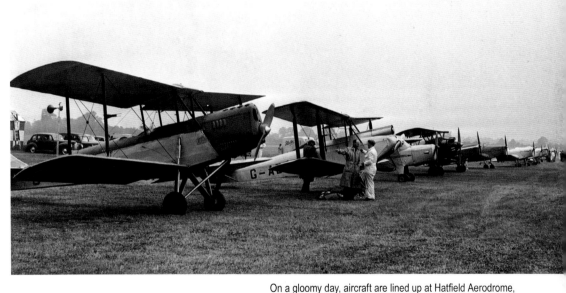

On a gloomy day, aircraft are lined up at Hatfield Aerodrome, in Hertfordshire for the start of the 1951 King's Cup Air Race. Most of the machines are of prewar vintage, but they would have no chance to display their paces, as the race would be abandoned due to poor weather conditions.

23rd June, 1951

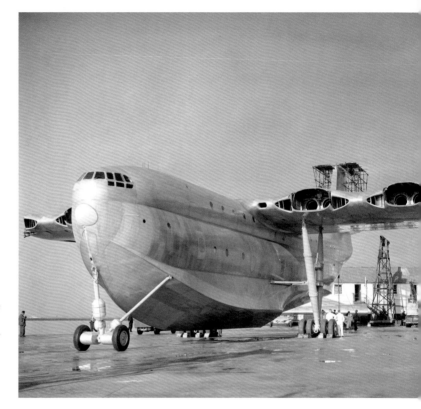

Last of the breed. The huge bulk of a Saunders-Roe Princess flying boat, undergoing final assembly, dwarfs the engineers at the Columbine Works at East Cowes on the Isle of Wight. The huge machine had two decks, but sadly was out of its time and never saw service.

30th October, 1951

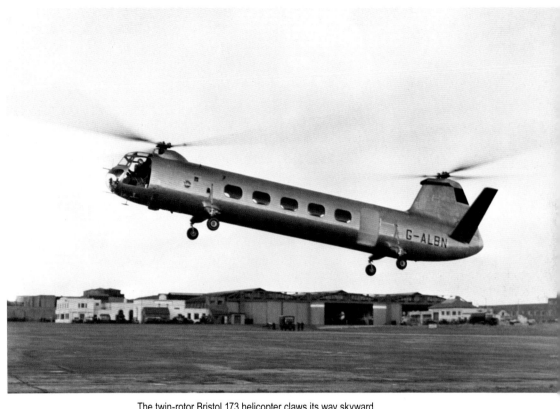

The twin-rotor Bristol 173 helicopter claws its way skyward
on its first test flight at Filton Airfield, Bristol. This was Britain's
first tandem-rotor helicopter, and after a considerable period
of development, it led to the production of the Bristol 192
Belvedere, which entered service with the Royal Air Force
in 1961 as a general-transport helicopter.
3rd January, 1952

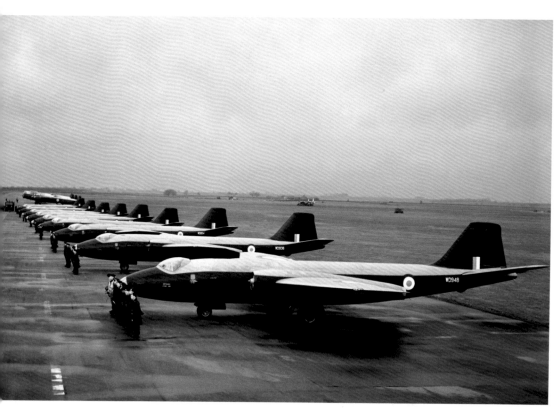

Aircrew, ground crew and aircraft of the Royal Air Force's No 101 Squadron line up on the runway at RAF Binbrook, Lincolnshire for inspection. The squadron was the first jet bomber unit in the RAF, being equipped with the English Electric Canberra B2. It was also the first RAF squadron to drop bombs from a jet in anger when carrying out counter-insurgency work in Malaya in 1955.

8th January, 1952

Facing page: The crew repositions a Blackburn Firebrand fighter on the deck of the aircraft carrier HMS *Eagle*. Developed as a naval strike fighter during the Second World War, it was capable of carrying bombs or a torpedo. It had poor low-speed handling, however, and the Royal Navy considered it unsuitable for carrier use. It was not until the end of the war that a more acceptable version, the TF Mk 4, was introduced.

18th March, 1952

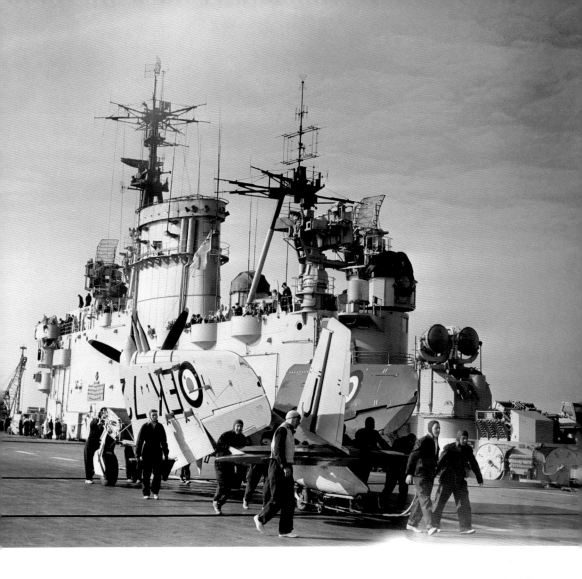

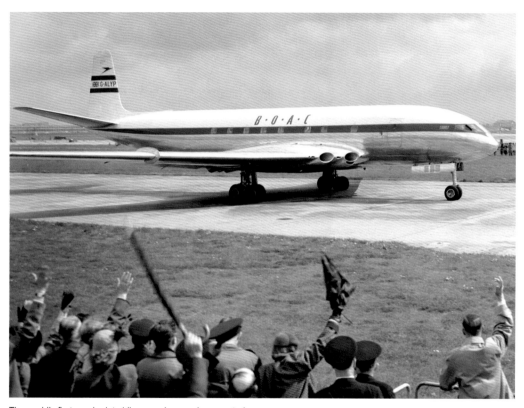

The world's first regular jet airliner service was inaugurated on 2nd May, 1952 when a 36-seat de Havilland Comet of British Overseas Airways (BOAC) took off from London's Heathrow Airport on a flight to Johannesburg, South Africa. The Comet was the world's first commercial jet airliner, having first taken to the air in 1949.

2nd May, 1952

Facing page: Lord Douglas, chairman of British European Airways, steps from a Bristol Type 171 helicopter after landing at the South Bank, London. The 171 was the first helicopter to enter Royal Air Force service, the military version being known as the Sycamore. It was used for search and rescue operations and anti-submarine warfare.

31st July, 1952

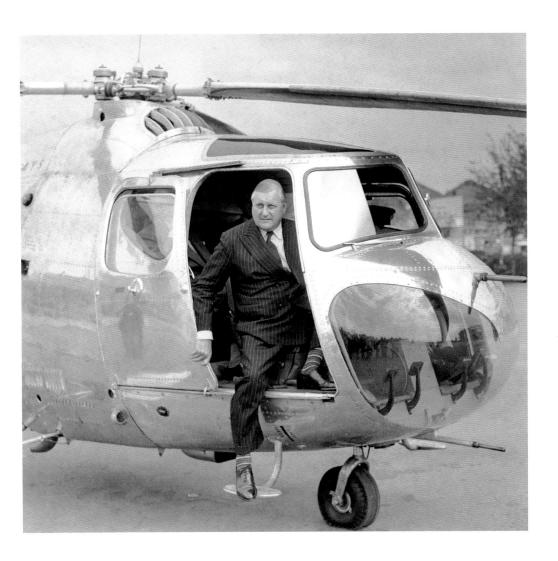

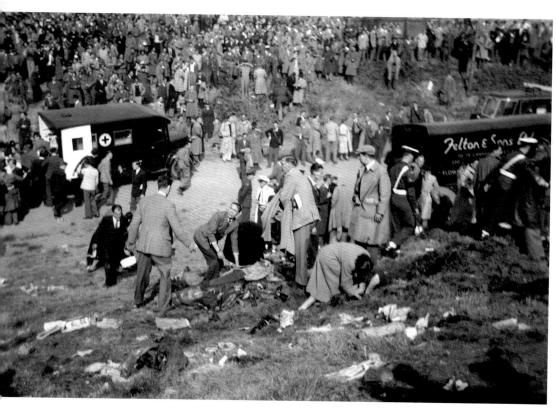

The aftermath of the crash of the prototype de Havilland
DH110 all-weather jet fighter at the 1952 Farnborough air show.
Thirty-one people were killed, including pilot John Derry and
his observer, Anthony Richards, while many more spectators
were injured. During Derry's aerobatic display, the machine had
broken apart due to a design flaw, crashing into the crowd.
6th September, 1952

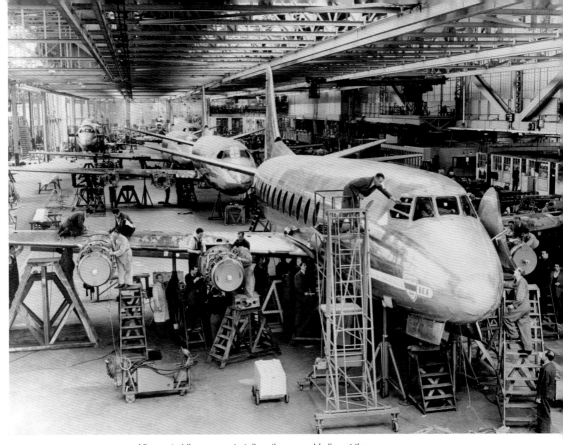

Viscount airliners nose to tail on the assembly line at the Vickers-Armstrong factory at Brooklands, near Weybridge in Surrey. Powered by four Rolls-Royce Dart turboprop engines (it was the first commercial aircraft so equipped), the Viscount had a range of 1,250 miles and could carry 48 passengers. It was one of the most successful transport aircraft developed in the immediate postwar period, 445 being built.

25th November, 1952

Actor Alec Guinness stands in front of a Mk 9 Spitfire during filming of *The Malta Story*, in which he played the role of Pilot Officer Peter Ross, a character loosely based on real-life RAF hero Adrian Warburton, a fearless reconnaissance pilot. Warburton disappeared on 12th April, 1944, while flying a photographic mission over Germany. His remains and aircraft were discovered in 2002, buried deep in a field near the village of Egling an der Paar, 34 miles southwest of Munich.

12th January, 1953

This group of cheerful Royal Air Force pilots demonstrates the camaraderie that existed between the various forces of the United Nations during the Korean War, where they were flying F-86 Sabre jet fighters with a unit of the United States Air Force. L–R: Timothy J. McElhaw, James A. Mansell, John H.J. Lovell, Roy French, John R. Dickinson, John R. Maitland, James A. Ryan, John E.Y. King, John H. Granville-White and John N. Murphy.
4th May, 1953

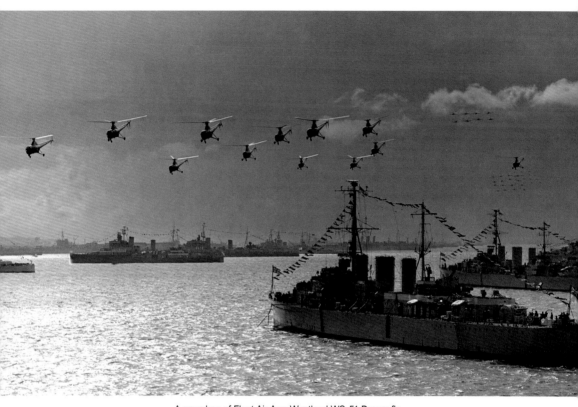

A squadron of Fleet Air Arm Westland WS-51 Dragonfly helicopters flies over HMS *Manxman* during the Coronation Fleet Review at Spithead in the Solent, off Hampshire. The review of the Royal Navy's fleet by the monarch is a tradition that goes back hundreds of years, and in 1953 it also celebrated the recent coronation of Queen Elizabeth II.
15th June, 1953

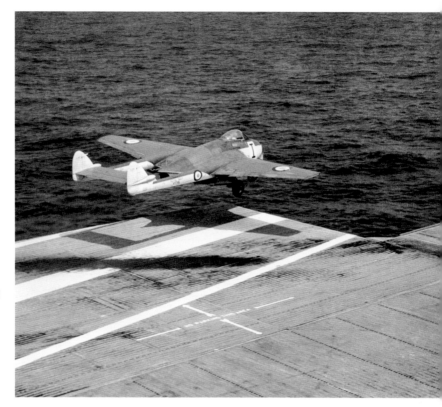

A Royal Navy de Havilland S20 Sea Vampire is catapulted from the deck of the US Navy's aircraft carrier USS *Antietam* during a joint exercise at sea. A Sea Vampire, flown by naval test pilot Eric 'Winkle' Brown, carried out the first carrier deck landing and take-off by a jet aircraft on 4th December, 1945.

1st July, 1953

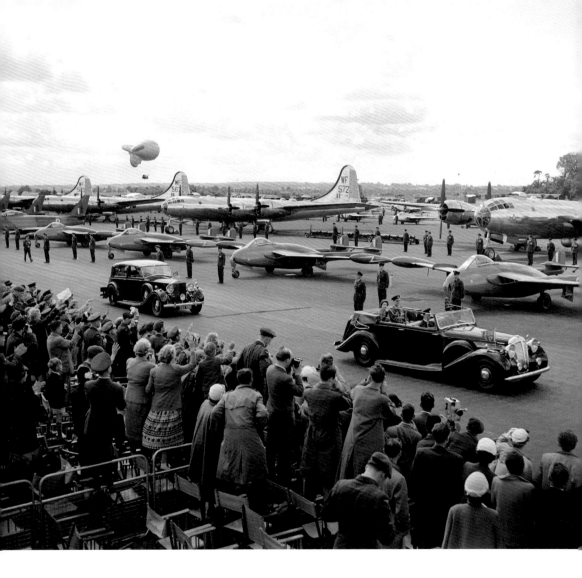

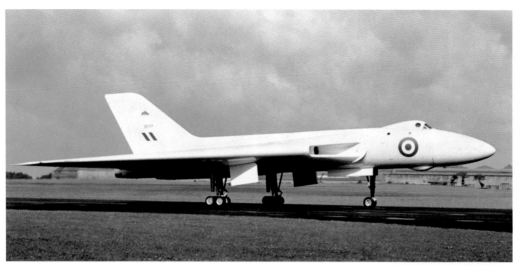

Facing page: Driven in an open-top car past a line of de Havilland DH112 Venom jet fighters with American B29 Superfortress bombers in the background, Queen Elizabeth II, accompanied by the Duke of Edinburgh, carries out the Coronation Review of the Royal Air Force, at RAF Odiham, Hampshire. With over 318 machines on the ground and over 600 taking part in a fly-past, the review was the biggest parade of aircraft in the history of the service.
15th July, 1953

The second prototype of the Avro Vulcan delta-wing jet bomber made a successful first flight from Woodford, Cheshire. Known initially as the Type 698, it would be given the official name Vulcan in late 1953. Together with the Vickers Valiant and Handley Page Victor, it would help form Britain's V-bomber nuclear deterrent.
4th September, 1953

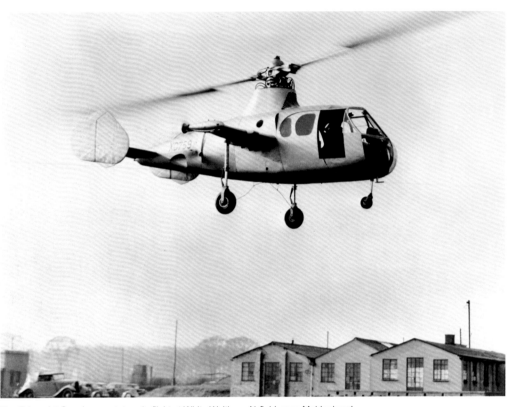

The Fairey Jet Gyrodyne prototype in flight at White Waltham Airfield, near Maidenhead, Berkshire. The Gyrodyne was a curious machine with a powered rotor that provided vertical take-off and landing, while small propellers at the tips of the stub wings drove it forward. Fairey eventually abandoned the project, but other manufacturers have experimented with the concept and continue to do so.

18th March, 1954

An American-built Hiller OH-23 Raven helicopter being rolled out of its hangar aboard HMS *Vidal*, an oceanographic survey ship belonging to the Royal Navy. Normally equipped with skids, the machine was fitted with wheels so that it could be manoeuvred on deck. The *Vidal* was the first small ship of the Royal Navy to be designed to carry a helicopter.

30th March, 1954

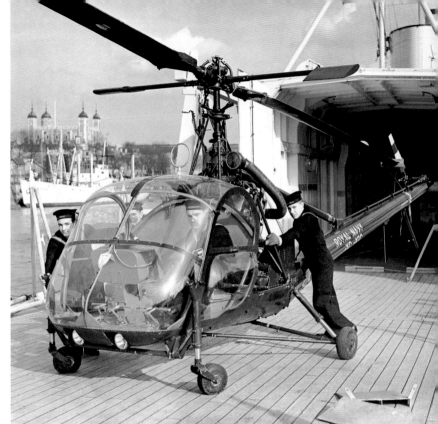

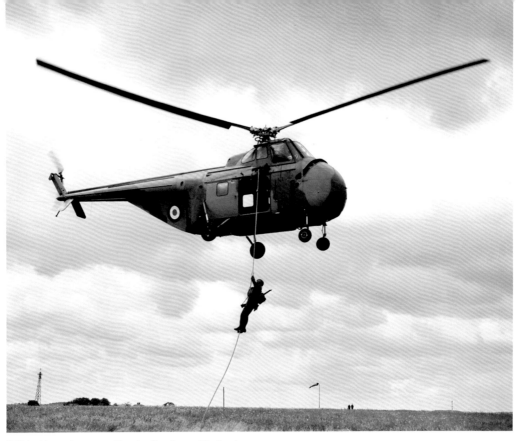

British airborne troops practise abseiling from a Westland Whirlwind helicopter. The Whirlwind was a licence-built version of the American Sikorsky S-55, being used by both the Royal Navy and Royal Air Force.
20th August, 1954

Facing page: Engineers at work on the engines of the British Overseas Airways Stratocruiser *Canopus* in the servicing shed at London's Heathrow Airport. Another Stratocruiser receives similar treatment in the background. The double-deck Stratocruiser was built by Boeing in the United States and had been developed from the B50 Superfortress bomber.
26th January, 1955

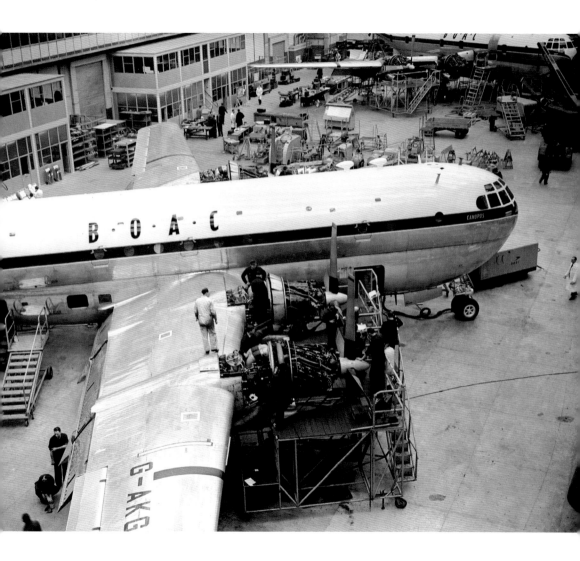

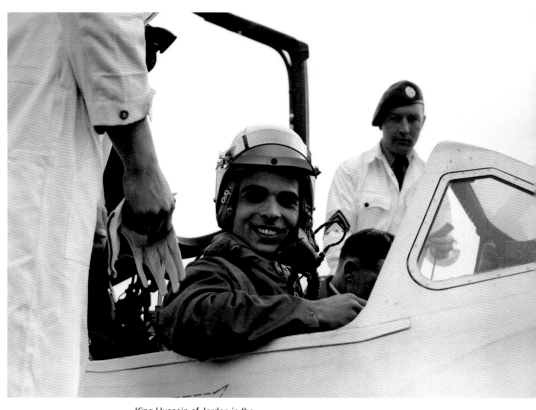

King Hussein of Jordan in the cockpit of a Vampire T11 jet trainer at RAF Biggin Hill in Kent while on an official visit to Britain. The king was a keen pilot and qualified to fly a large number of machines.
21st June, 1955

The first prototype of the Fairey Ultra-light helicopter during its maiden flight at White Waltham Airfield, Berkshire. The machine had been developed as a low-cost and easily transportable military helicopter suitable for reconnaissance and casualty evacuation. It showed considerable promise, but the project was axed by cuts in defence expenditure.

23rd July, 1955

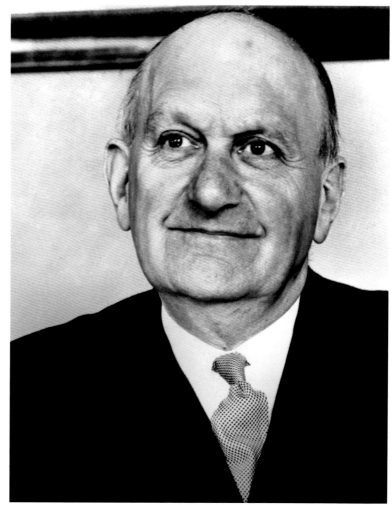

British aviation pioneer Sir Frederick Handley Page, whose company built the Victor strategic jet bomber. Page had formed the company in 1909, and it became known for producing heavy bombers, such as the Second World War Halifax, and large commercial aircraft like the HP42 biplane airliner of the inter-war years.

11th January, 1957

For a while in the mid-1950s, a site on the South Bank was used as an experimental helicopter landing pad serving central London. Other plans for the area and concerns about noise, however, led to its closure in 1957. Here passengers disembark from the last helicopter to land there, a Westland Dragonfly. L–R: Richard Fairey, vice-chairman of Fairey Aviation (who piloted the machine), Mrs Atalanta Fairey, Mrs Maudling, Paymaster-General Reginald Maudling.
1st July, 1957

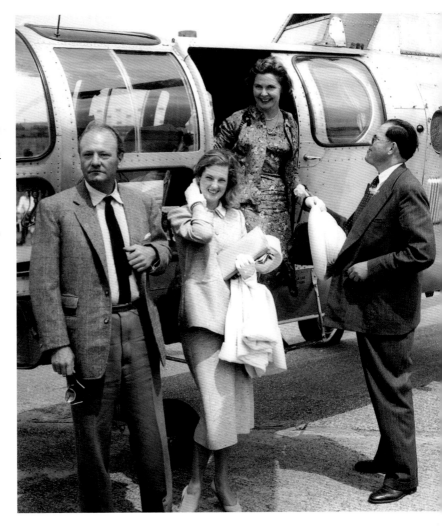

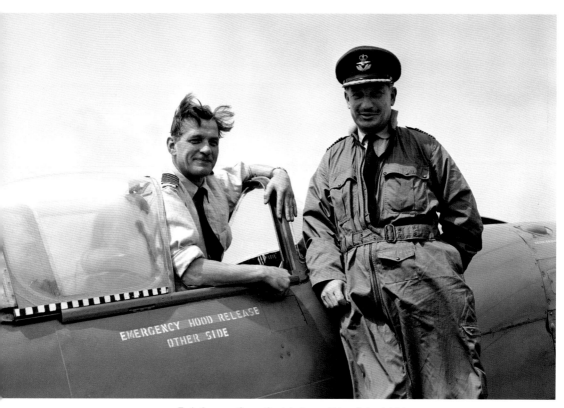

End of an era. Group Captain James Edgar 'Johnnie' Johnson
(L) and Group Captain James Rankin at RAF Biggin Hill, Kent,
after delivering two of the last three Spitfires in RAF service for
their retirement. Johnson was the top scoring Allied fighter pilot
of the Second World War, having downed 38 German aircraft,
while Rankin had 22 kills to his name.
11th July, 1957

EMERGENCY HOOD RELEASE
OTHER SIDE

The control tower under construction at the new Gatwick Airport. Flying began at Gatwick in the 1920s, and commercial flights were inaugurated in the mid-1930s. However, it was not considered suitable for major development until 1950, when the government decreed that it would be London's second airport. The airport was closed between 1956 and 1958 for a £7.8m renovation, being opened by Queen Elizabeth II on 9th June, 1958.
22nd July, 1957

L–R: Architect Francis Reginald Stevens Yorke, engineer
Frederick Snow and Parliamentary Secretary to the Ministry
of Transport Airey Neave examine a model of the proposed
administrative buildings at the new Gatwick Airport.
22nd July, 1957

Tickling the ivories. Television entertainer Hughie Green sits at the piano and is joined in a song by Ronnie Ronalde and Rosalina Neri aboard a BOAC Britannia airliner at London's Heathrow Airport. They were rehearsing for a special flight to New York that would be filmed for screening as 'Jack Hylton's Monday Show'.
28th January, 1958

The wreckage of the British European Airways Airspeed Ambassador that was carrying the Manchester United football team back from a match in Belgrade, Yugoslavia. After refuelling in Munich, the machine crashed as it tried to take off from a snow-covered runway, killing 23 people, including eight of the team's players.

6th February, 1958

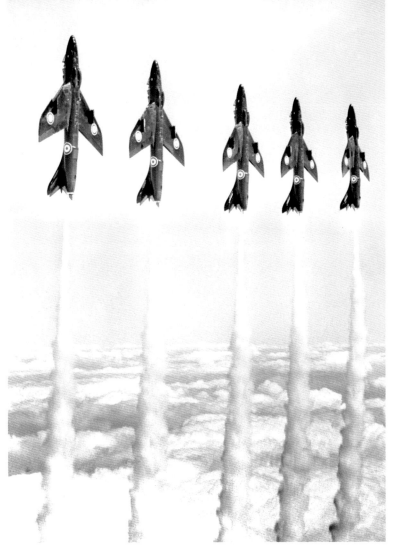

Five Hawker Hunter jet fighters of the Royal Air Force's No 111 Squadron, which acted as the RAF's aerobatic team, known as the Black Arrows. Renowned for its formation flying, 'Treble One' Squadron achieved a record in 1958 by flying a 22-jet formation loop.
5th May, 1958

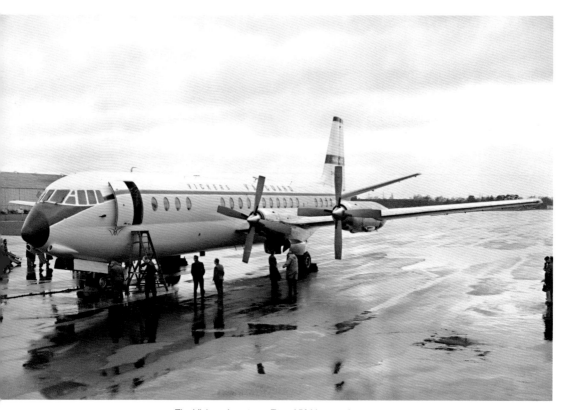

The Vickers Armstrong Type 950 Vanguard prototype turboprop airliner being prepared for its maiden flight from the factory's airfield at Brooklands, near Weybridge in Surrey. Developed from the Viscount, it arrived at a time when the airlines were switching to jets and, as a consequence, was only produced in small numbers. Most became cargo carriers.
20th January, 1959

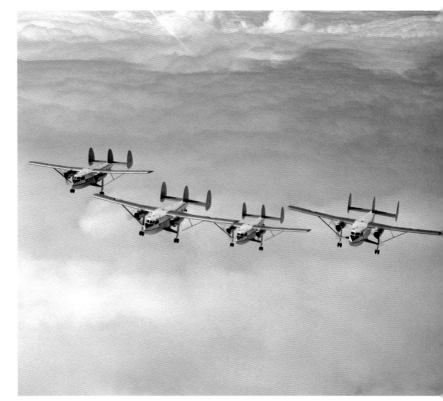

A flight of four Scottish Aviation Twin Pioneer CC1 transport aircraft from RAF Benson in Oxfordshire. The Twin Pioneer was a rugged machine that offered a short-take-off-and-landing (STOL) capability. It was used primarily for military purposes, although some civilian examples were employed in bush flying.

12th August, 1959

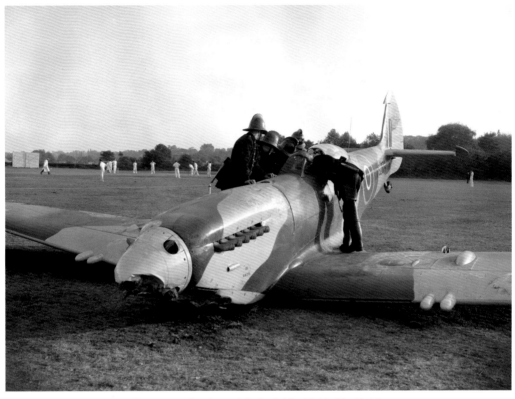

Firemen peer into the cockpit of a Spitfire Mk 16 of the Royal
Air Force's Battle of Britain Flight, based at RAF Biggin Hill,
that had crash-landed on a cricket pitch in Bromley, Kent,
minutes after leading a Battle of Britain commemorative
fly-past over London. The machine had suffered a complete
engine failure. Subsequently, it was rebuilt for static display.
20th September, 1959

"It works like this..." Sir Frank Whittle explains the intricacies of a Boeing 707 jet engine to actress Janette Scott at London's Heathrow Airport. Whittle was one of two men who independently had invented the jet engine in the 1930s, the other being German scientist Hans von Ohain. There was a remarkable lack of enthusiasm for Whittle's work from official quarters, however, until Germany's interest was discovered.
24th November, 1959

Dr Barnes Wallis, who had collaborated on the R100 airship and the Vickers Wellington bomber, and had developed the 'bouncing' bombs used by the Royal Air Force in the 'Dambusters' raid, contemplates his latest scheme, the supersonic Swallow variable-geometry aircraft. A number of models were built to test Wallis' theories, but defence cuts brought an end to further development, although the Americans used his variable-geometry ideas on the General Dynamics F-111 bomber.

30th December, 1959

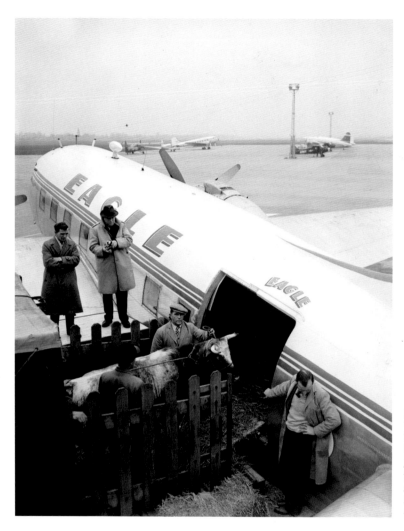

Prize bull Hinxhill Pearl 13th is led aboard a Vickers Viking freighter of British Eagle Airways at Gatwick Airport, Sussex for a flight to Scotland, where the animal would take part in the Scottish Dairy Show.
10th February, 1960

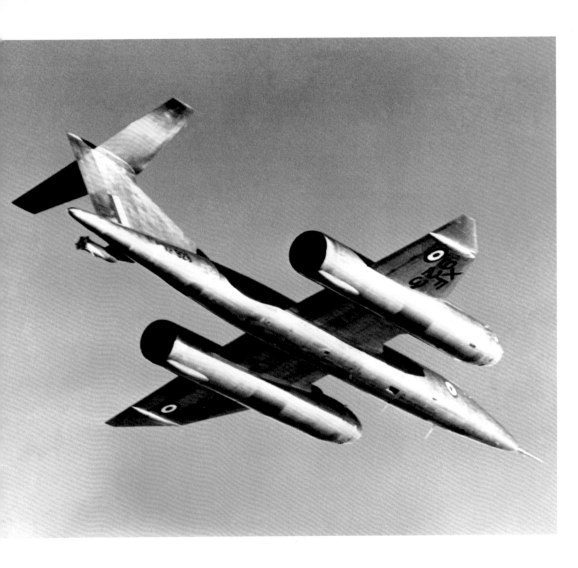

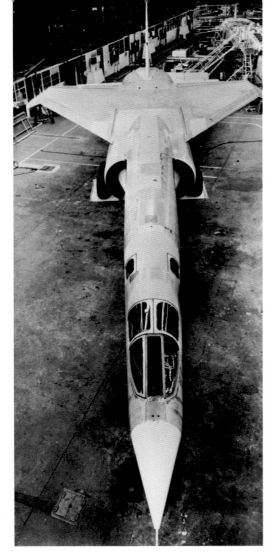

The TSR-2, a revolutionary new bomber designed for the Royal Air Force, under construction by the British Aircraft Corporation at Brooklands, near Weybridge in Surrey. The machine was intended as a low-level strike aircraft, and was touted as the most advanced and versatile aircraft in the world.
The project was cancelled in favour of the American-built General Dynamics F-111, however, a procurement that was also cancelled shortly after.
28th October, 1963

Facing page: The Bristol Type 188, a British supersonic research aircraft nicknamed 'The Flaming Pencil'. The data gleaned from this aircraft would be used by the designers of the Concorde airliner.
25th June, 1962

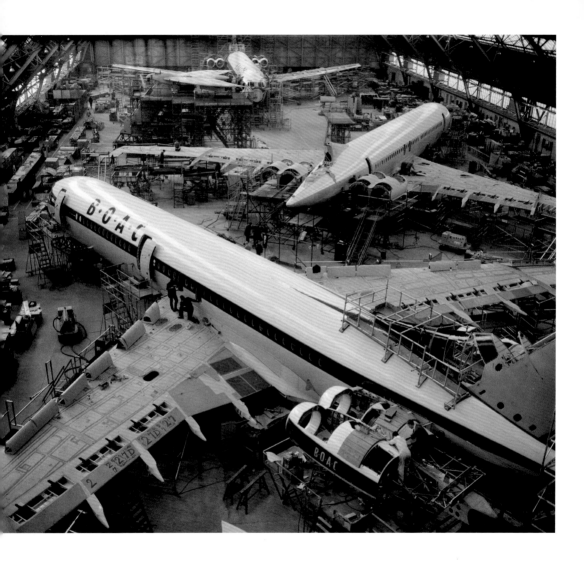

Sky cops. A Westland Sioux helicopter takes part in a line-up of vehicles operated by London's Metropolitan Police. The Sioux was a licence-built version of the American Bell 47, which had been the first helicopter certified for civilian use in March 1946.

9th March, 1964

Facing page: Vickers VC10 jet airliners being built at the British Aircraft Corporation's vast assembly hall at Brooklands in Surrey. The VC10 had high fuel consumption and generated high noise levels on take-off and landing, which largely sealed the aircraft's fate. By the early 1980s, most had been retired from commercial use, although the RAF continued to use them as transports and aerial tankers.

27th January, 1964

Joan Hughes prepares to fly a replica 1909 Demoiselle monoplane built for *Those Magnificent Men in their Flying Machines*. Born in 1918, Joan had spent much of her life in aviation, having become the youngest woman pilot in Britain at the age of 17. A member of the Air Transport Auxiliary during the Second World War, she became the only woman qualified to instruct on all wartime military aircraft.

22nd April, 1964

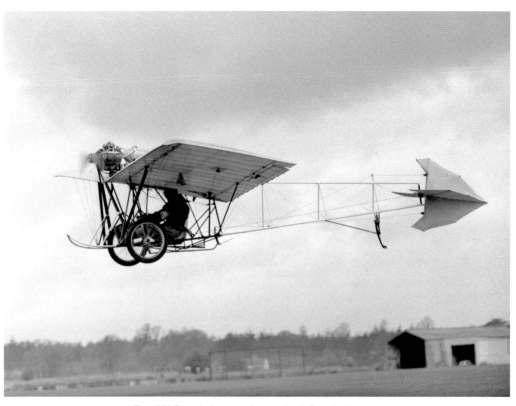

The 1909 Demoiselle monoplane replica is flown by Joan
Hughes, test pilot and instructor at the Airways Flying Club,
White Waltham, near Maidenhead, Berkshire. Although
correct in many details, the machine relied on a modified
VW Beetle car engine for power.
22nd April, 1964

A British European Airways American-built Sikorsky S-61 helicopter, operating from Battersea Heliport in London, made 25 journeys across the Thames to Fulham Power Station, carrying materials needed to replace a gas flue duct on the roof. Subsequently, the S-61 was built under licence in Britain by Westland as the Sea King.

5th April, 1965

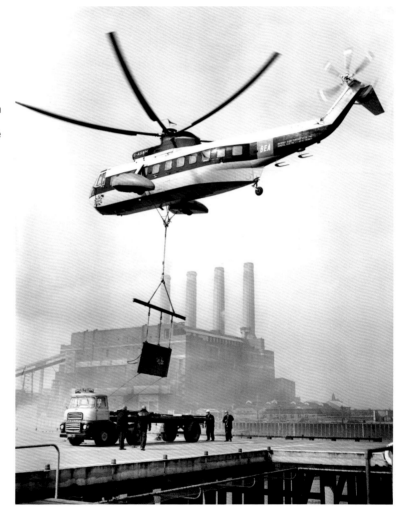

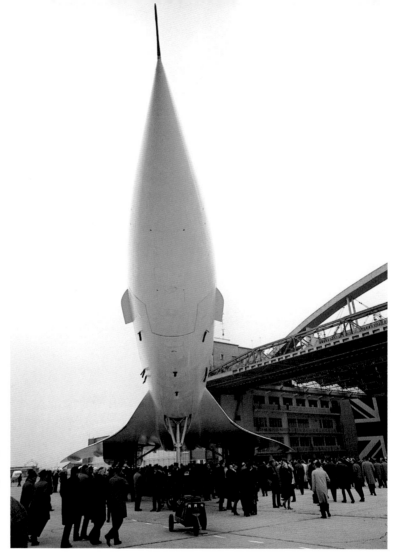

Like a missile on the launch pad, the long pointed nose of the first prototype Concorde, the Anglo-French supersonic jet airliner, towers above the crowd after the machine was rolled out for the first time at Toulouse in France.
11th December, 1967

The skeletal remains of the tail rear above the blackened wreck of a BOAC Boeing 707 that crashed in flames at London's Heathrow Airport only four minutes after take-off. Remarkably, of the 127 people on board, 122 survived. There were five fatalities, among them Barbara Jane Harrison, a flight attendant, who had remained inside the blazing aircraft helping passengers to escape. For her bravery, she was awarded the George Cross.

8th April, 1968

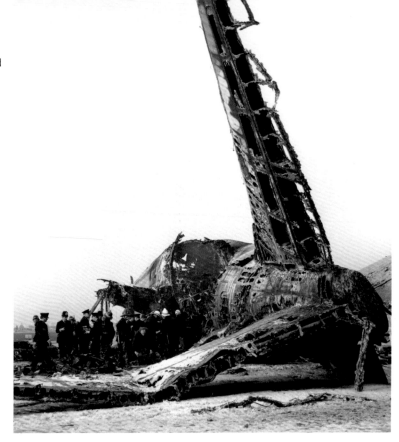

Second World War Hurricanes and Spitfires assembled at RAF Henlow, Bedfordshire, for the filming of *The Battle of Britain*. The Spanish Air Force provided their 'opponents', Spain having built German Messerschmitt 109 fighters and Heinkel 111 bombers under licence. Standing in the cockpit of the nearest Hurricane is former British fighter pilot Robert Stanford-Tuck, who downed ten aircraft during the battle.

18th April, 1968

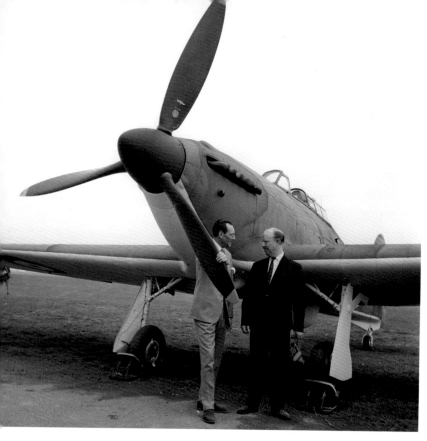

Former successful Second World War fighter pilots Flight Lieutenant James 'Ginger' Lacey (R) and Wing Commander Robert Stanford-Tuck remember old times in front of a British Hurricane fighter at RAF Henlow, Bedfordshire. The two veterans had been employed as consultants on the film *The Battle of Britain*.
18th April, 1968

A beaming Brian Trubshaw, captain of Concorde 002, at RAF Fairford, Gloucester, where the machine landed after its successful maiden flight from Filton, near Bristol. His comment on emerging from the flight deck: "*It was wizard, a cool, calm and collected operation.*"
9th April, 1969

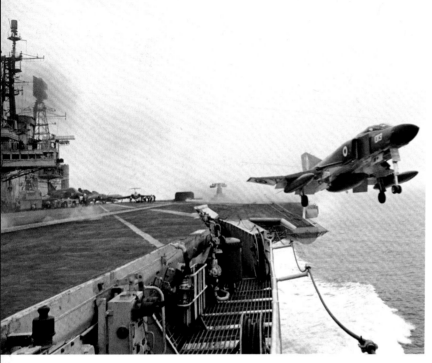

An American-built
McDonnell-Douglas F-4
Phantom of the Royal Navy's
Fleet Air Arm is launched
from the flight deck of HMS
Ark Royal. The Phantom,
a two-seat fighter-bomber,
served with both the Navy
and the Royal Air Force,
being equipped with British
engines and avionics.
10th May, 1970

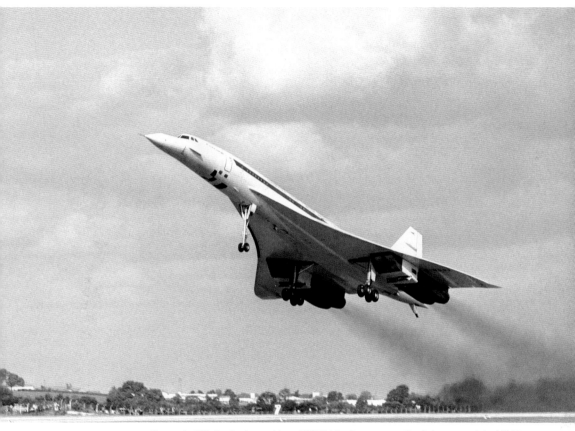

Concorde 002 shoots skyward from RAF Fairford's runway on the first supersonic test flight over land. The flight, along Britain's west coast, ushered in the Concorde age, double bangs being heard at monitoring stations at Oban in Scotland and St David's in Wales. The aircraft completed the trip on three engines after the fourth overheated.
1st September, 1970

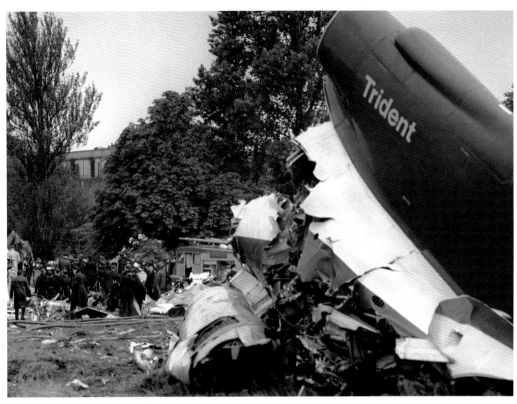

An engine nacelle still intact on the tail section of a British European Airways Trident airliner that had crashed in a field in Staines, Middlesex, killing all 118 people on board. The jet had come down shortly after taking off from London's Heathrow Airport after entering a deep stall, from which the pilots were unable to recover. Until the Lockerbie disaster in 1988, this was Britain's worst air crash.
18th June, 1972

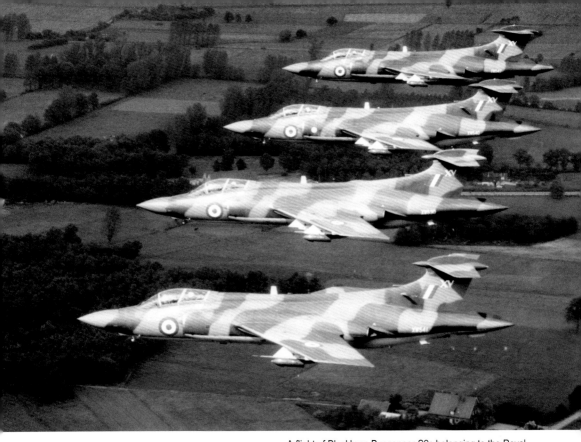

A flight of Blackburn Buccaneer S2s belonging to the Royal Air Force's No 16 Squadron, based at RAF Laarbruch in West Germany. The Buccaneer, a low-level strike aircraft with nuclear capability, was developed originally as a naval aircraft, but it was flown by both the Fleet Air Arm and the Royal Air Force.

9th July, 1972

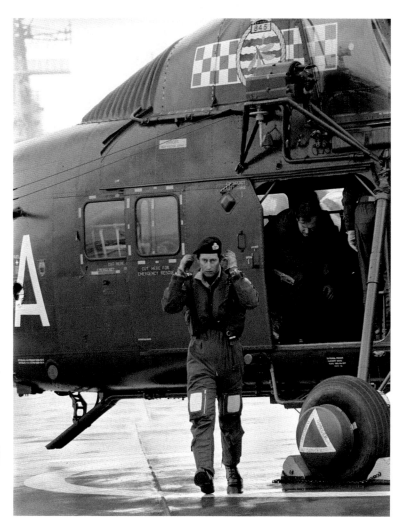

Lieutenant the Prince of Wales adjusts his beret after landing a Royal Navy Westland Wessex helicopter aboard the commando ship HMS *Hermes* while serving as a member of 845 Squadron. The Wessex was a turbine powered British-built version of the American Sikorsky S-58 Choctaw, and was used by both the Navy and Royal Air Force as a general transport helicopter.

10th March, 1975

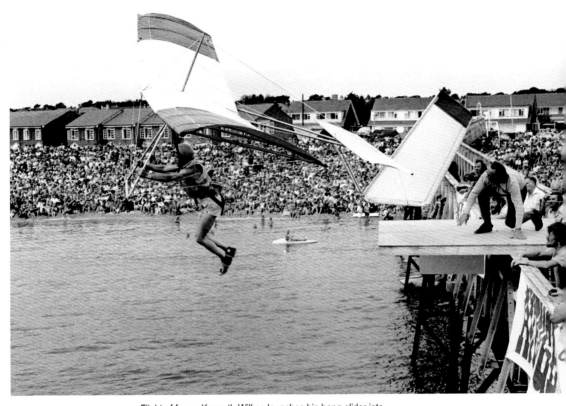

Flight of fancy. Kenneth Wilkes launches his hang glider into
the air from a platform 30ft above the sea during the annual
International Birdman Rally at Selsey in West Sussex.
Unfortunately, he failed in his attempt to cover a distance of 50m.
10th August, 1975

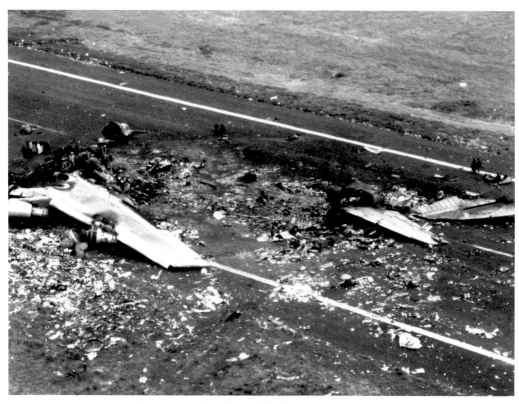

The wreckage of two Boeing 747 airliners, belonging to
the Dutch and American airlines KLM and Pan Am,
which had collided in thick fog on the runway of Los Rodeos
Airport, Tenerife. It was the worst accident in aviation history,
killing 583 people.
28th March, 1977

High flyer. A jubilant Sir Freddie Laker, at Gatwick Airport, celebrating his return to the airline business with Skytrain. Laker, who had a long history in the industry, was one of the first to offer a 'no-frills' service and cut-price fares.

14th July, 1979

Lady Tavistock inspects a de Havilland Tiger Moth outside
Woburn Abbey for the celebration of the record-breaking
flight made by the Duchess of Bedford (Lord Tavistock's
grandmother) from England to Cape Town, South Africa,
in 1930. Every year, the grounds of Woburn become a
temporary airfield for a Moth rally.
1st August, 1980

Crew members together with Sea Harrier FRS Mk 1 jet fighters
and Sea King Mk 4 helicopters line the flight deck of HMS
Hermes as the ship passes the Round Tower, Portsmouth, at
the beginning of a voyage to the South Atlantic. The *Hermes*
was the flagship of the British fleet sent to repel the Argentine
invasion from the Falkland Islands.

5th April, 1982

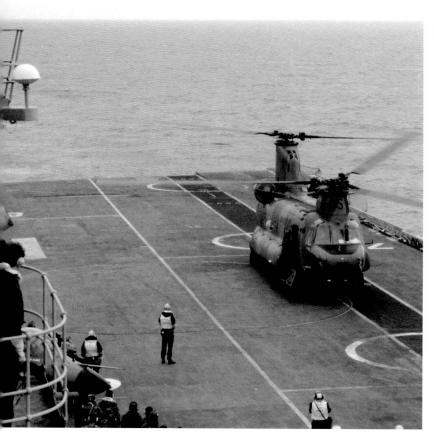

On the way to the Falklands, the flight deck of HMS *Hermes* is a hive of activity. A Royal Air Force Boeing HC1 Chinook is on the deck preparing to depart, while a flight of Westland Sea King Mk 4 helicopters approaches for landing.
6th April, 1982

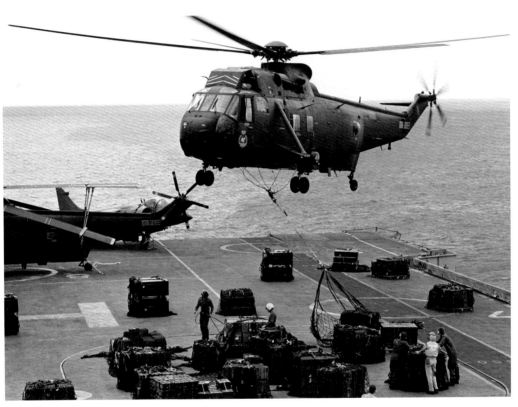

A Westland Sea King
helicopter hovers above
HMS *Hermes* to airlift
ammunition, taken on
board at Portsmouth, for
distribution to other ships in
the task force.
19th April, 1982

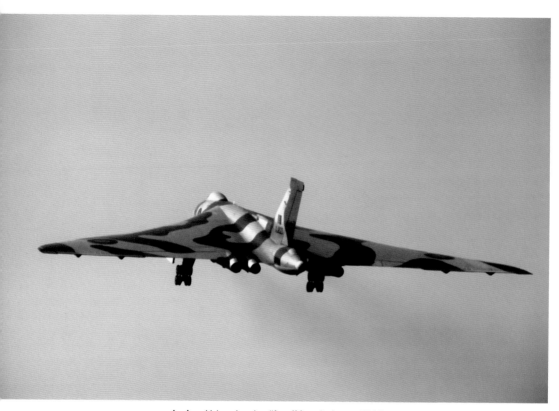

An Avro Vulcan bomber lifts off from its base at RAF
Waddington, Lincolnshire. Although developed to deliver
nuclear weapons, the Vulcan could also carry conventional
bombs. It was used for this purpose during the Falklands
War, the only time the aircraft saw action.
19th April, 1982

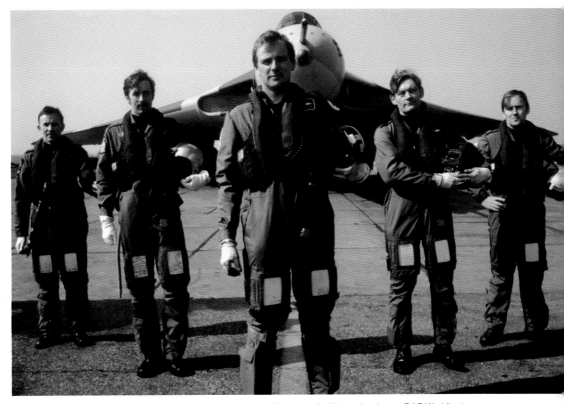

The crew of a Vulcan bomber at RAF Waddington, Lincolnshire. The last Vulcan bombers in RAF service were due to be scrapped in 1982, but they were given a new lease of life as long-range bombers due to the Falklands crisis. They soldiered on until 1984.

19th April, 1982

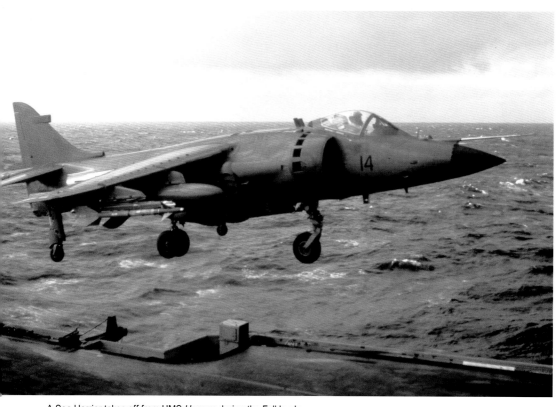

A Sea Harrier takes off from HMS *Hermes* during the Falklands crisis. The vertical-take-off-and-landing (VTOL) fighter provided the Royal Navy with a versatile strike capability that could be deployed from relatively small aircraft carriers.
1st May, 1982

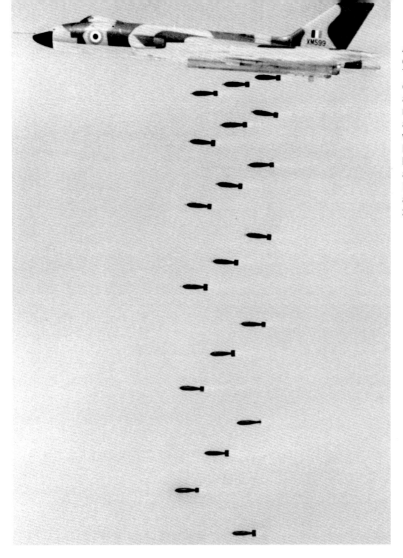

An Avro Vulcan carries
out a practice bomb drop.
The delta-wing bomber
could carry 21 bombs over
a considerable range and
make an accurate low-level
attack at night or in any
weather. Vulcan and Sea
Harrier jets successfully
bombed the Port Stanley
airstrip, on the Falkland
Islands, in two pre-dawn
attacks.
2nd May, 1982

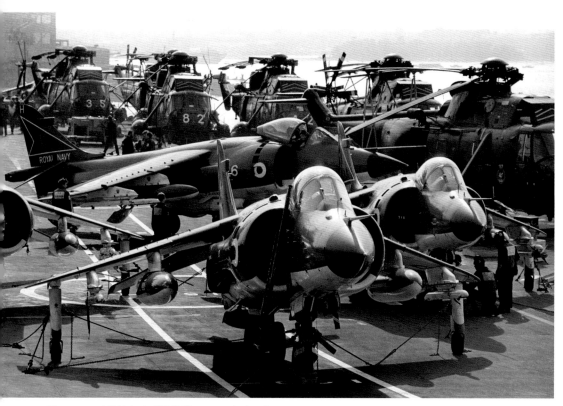

The crammed flight deck of HMS *Hermes* as she heads
south to the Falkland Islands. In front are British Aerospace
Sea Harrier FRS Mk 1s with Westland Sea King helicopters
behind. During the conflict, RAF Harriers also operated from
the *Hermes*.

6th May, 1982

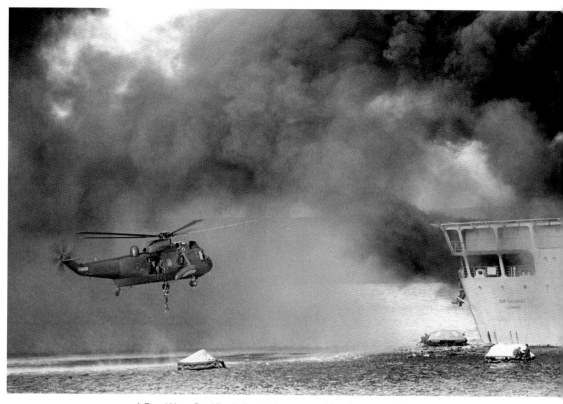

A Royal Navy Sea King helicopter hovers over life rafts containing survivors from the blazing British landing ship, RFA *Sir Galahad*, following a devastating air attack on the vessel and her sister ship, *Sir Tristram*. *Sir Galahad* was so badly damaged that she was towed into deep water and sunk.
8th June, 1982

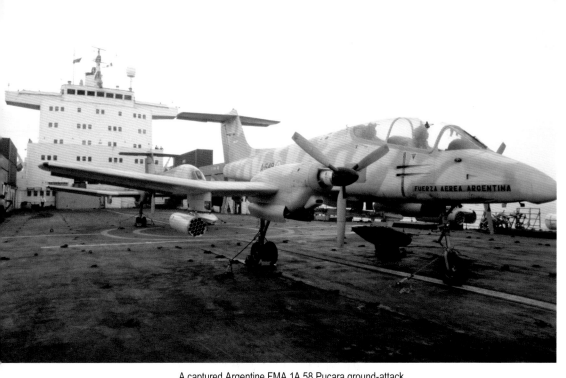

A captured Argentine FMA 1A 58 Pucara ground-attack
aircraft on the deck of the Cunarder *Atlantic Causeway*
on a voyage to Plymouth from the Falkland Islands following
the seizure of the islands by the British task force. Many
similar aircraft were destroyed on the airfield at Port Stanley
by British troops.
1st July, 1982

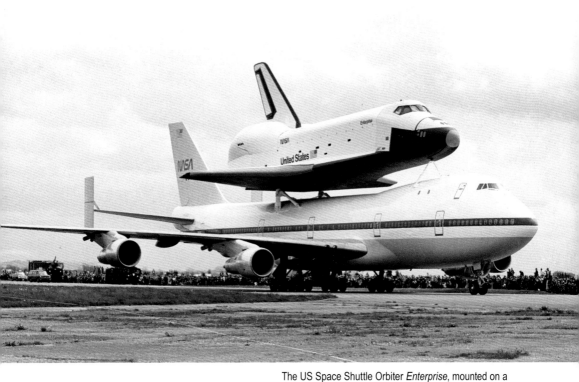

The US Space Shuttle Orbiter *Enterprise*, mounted on a modified Boeing 747 carrier aircraft during a brief stop for refuelling at RAF Fairford in Gloucestershire. The Shuttle was on its way to various displays in Europe, including the Paris air show.
20th May, 1983

An airliner is de-iced at London's Heathrow Airport on a snowy winter's day. The formation of ice on an aircraft can have fatal consequences, since it alters the shape of the wing surfaces, reducing the amount of lift produced. This can cause a machine to crash.

9th February, 1985

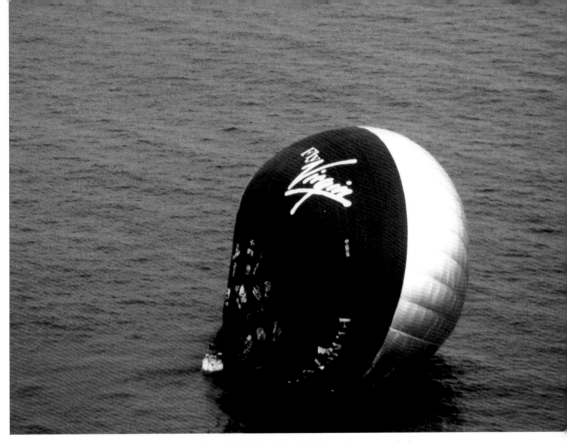

An undignified end to a historic voyage occurred when
the largest balloon ever made, the Virgin Atlantic Flyer,
foundered in the Irish Sea after its pilots, Richard Branson
and Per Lindstrand, baled out. However, Virgin Atlantic
chairman Branson did break the balloon speed record
in his attempt to be the first to cross the Atlantic in
a balloon.
6th July, 1987

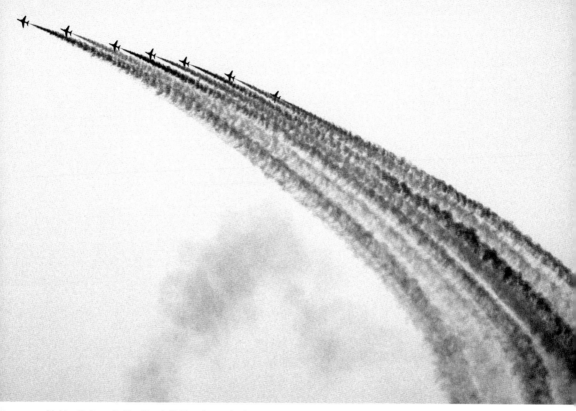

Making their mark. The Royal Air Force's aerobatic team, The Red Arrows, paints the sky with coloured smoke during a thrilling display of close formation flying. Based at RAF Scampton, in Lincolnshire, the team is made up of experienced instructors.
1st July, 1988

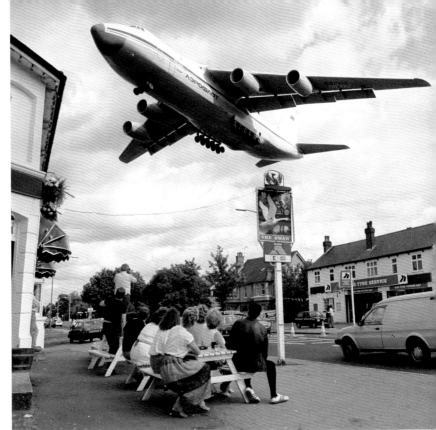

Customers enjoying a quiet lunchtime drink in Farnborough, Hampshire look skyward as a giant Soviet Antonov AN-124 transport, the largest aircraft in the world, roars over their heads on its way to a landing for the Farnborough air show.

30th August, 1988

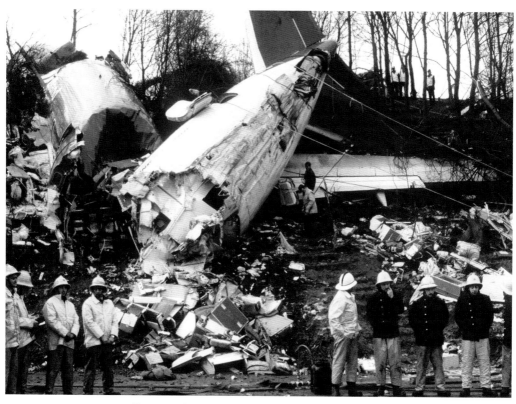

Rescue service personnel with the remains of a British
Midland Boeing 737-400, which had crashed on to
the embankment of the M1 motorway near Kegworth,
Leicestershire, following engine failure. The aircraft had been
attempting an emergency landing at East Midlands Airport.
Of the 126 people aboard, 47 died and 74, including seven
members of the flight crew, sustained serious injuries.
9th January, 1989

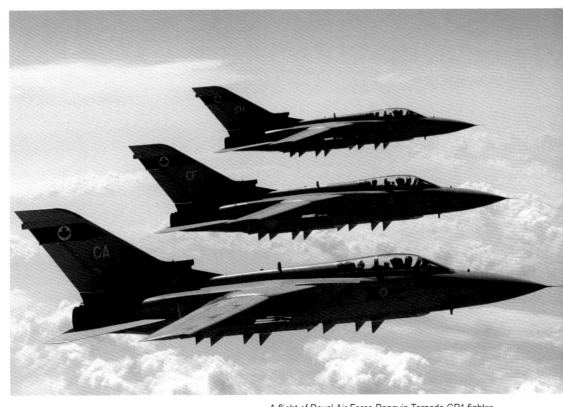

A flight of Royal Air Force Panavia Tornado GR1 fighter-bombers returning to RAF Brize Norton from Dhahran Military Air Base, Saudi Arabia, following a six-week deployment during the first Gulf War.
17th September, 1990

Some enthusiasts are so interested in the aircraft of the
First World War that they are prepared to recreate the
machines and demonstrate them in mock combat during
air shows. Here a replica of Manfred von Richthofen's red
Fokker Dr1 triplane sits with engine cowling removed during
maintenance work.

12th August, 1992

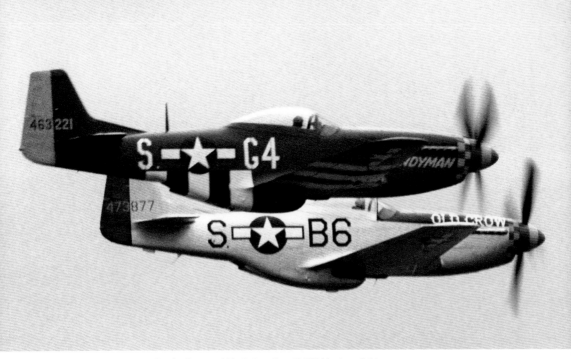

A pair of restored North American P-51D Mustang fighters makes a low fly-past at Duxford Airfield, near Cambridge, during an air show to mark the 50th anniversary of the arrival of the first units of the US Army Air Force in England during the Second World War.

28th August, 1992

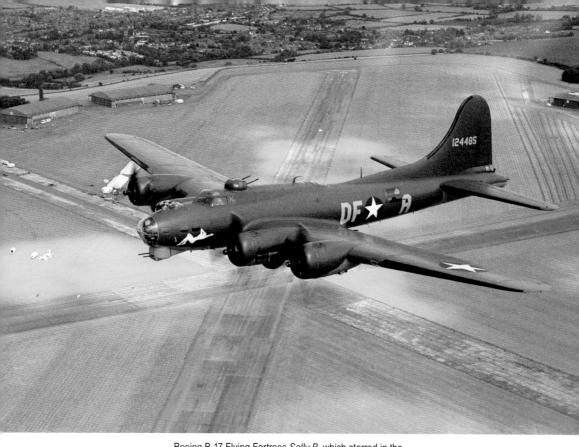

Boeing B-17 Flying Fortress *Sally B*, which starred in the
film *Memphis Belle*. The bomber, the only airworthy B17 in
Britain, is maintained as a flying memorial to the thousands
of American aircrew who lost their lives in Europe during the
Second World War.

28th August, 1992

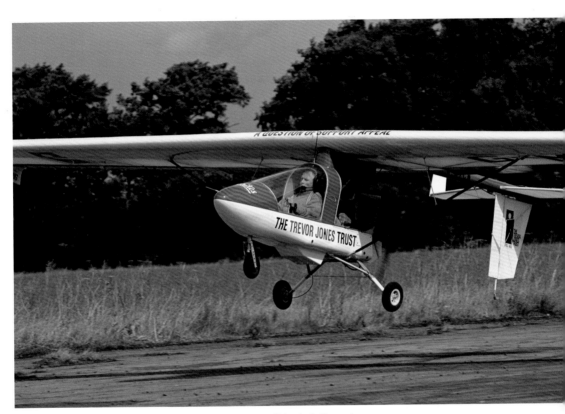

Tetraplegic Trevor Jones lands his microlight at Lichfield Aerodrome, Staffordshire. Jones was preparing for a record attempt on the flight time to cross the English Channel.
3rd September, 1992

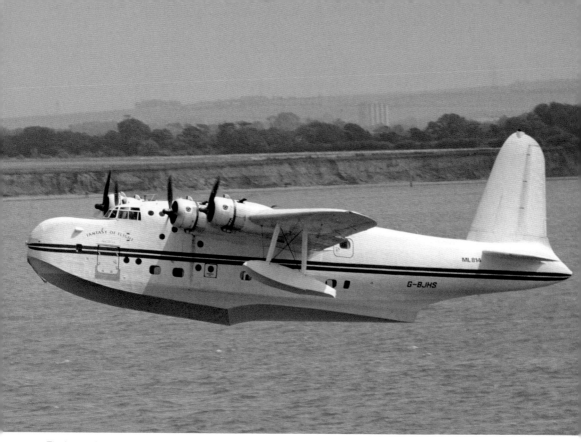

The last airworthy Short S25 Sunderland flying boat departs from Calshot, Hampshire, en route to its new home in Florida, where it would join American millionaire Kermit Weeks' historic aircraft collection. Sunderlands were used by the Royal Air Force during the Second World War to carry out anti-submarine patrols.

20th July, 1993

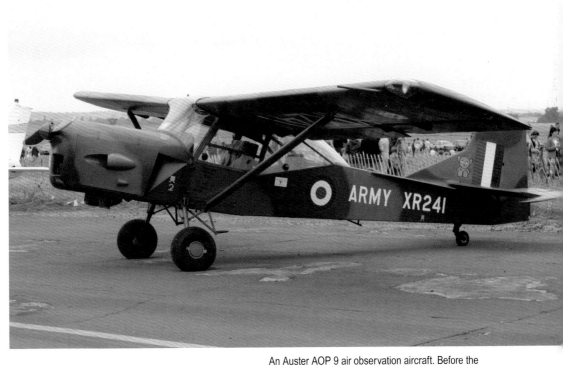

An Auster AOP 9 air observation aircraft. Before the predominance of helicopters, small fixed-wing machines like the Auster were used by the Army to carry out battlefield observation and artillery direction. They could operate from short rough airstrips, but their slow speed made them vulnerable to ground fire. The AOP 9 was the last of a long series of Austers.

7th August, 1993

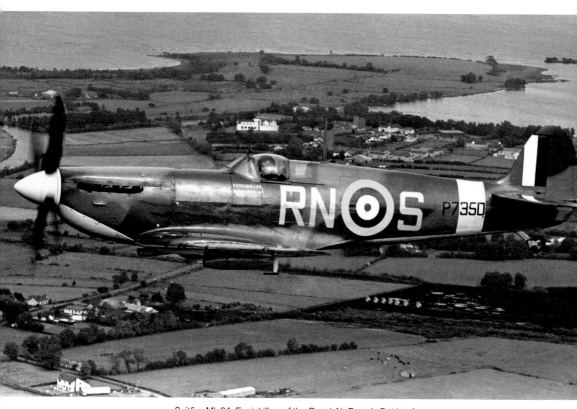

Spitfire Mk 2A *Enniskillen*, of the Royal Air Force's Battle of
Britain Memorial Flight and in the markings of 72 Squadron,
flies south of Lough Neagh in Northern Ireland to celebrate the
25th anniversary of the squadron's tour of duty in the province.
25th September, 1994

Veteran glider pilot Group Captain Edward Mole with a replica Scud glider at Brooklands Museum, Weybridge in Surrey, where it is on display. The Scud was a successful machine and was built originally in the early 1930s by Abbott-Baynes Sailplanes of Farnham, Surrey.

29th October, 1995

An Airship Industries Skyship non-rigid airship carrying Philips advertising flies over the City Ground, home of Nottingham Forest football club. Such modern airships are commonly used as flying television camera platforms for major sporting events.

10th December, 1995

Bill Davies, 78, of Shipstone on Stour, achieves his lifetime ambition of gaining a pilot's licence. Davies, who had taken up flying 18 months before, confounded Civil Aviation Authority medical examiners with his level of fitness. Previously his passion had been for racing motorcycles, and he took part in his last race at the age of 65.
22nd May, 1996

A group of colourful hot-air balloons floats over Clifton College at the start of the International Balloon Fiesta in Bristol. The annual event draws balloonists from all over the world, as many as 100 balloons being launched at once.
5th August, 1996

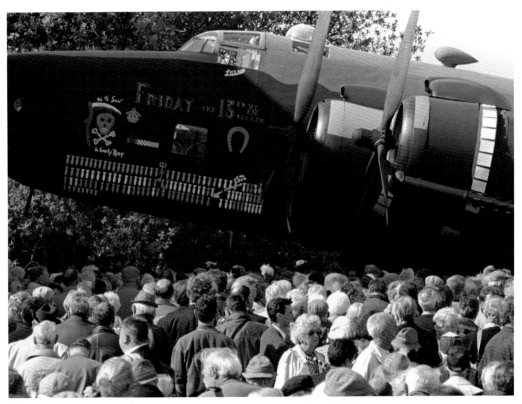

A replica of a Second World War Handley Page Halifax bomber is unveiled to visitors at the Yorkshire Air Museum, near York. The replica, which took enthusiasts 12 years to construct, recreates a machine named *Friday the 13th* and was built as a memorial to the many men of Royal Air Force Bomber Command who lost their lives during the conflict.
13th September, 1996

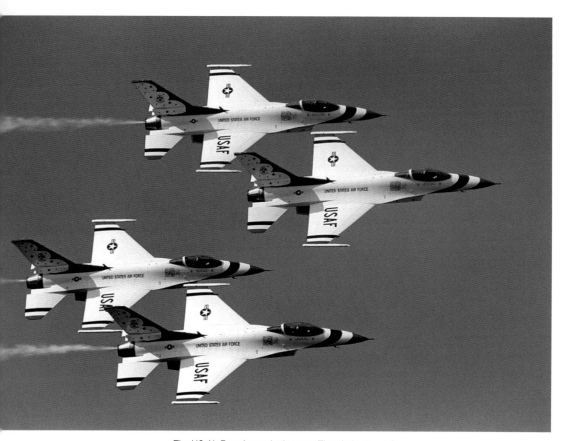

The US Air Force's aerobatic team, Thunderbirds, performs
its thrilling routine during Air Fete '97 at RAF Mildenhall as
part of a celebration of the 50th anniversary of the formation
of the USAF from the US Army Air Force. Their machines
are Lockheed-Martin F16 Fighting Falcon fighters.
25th May, 1997

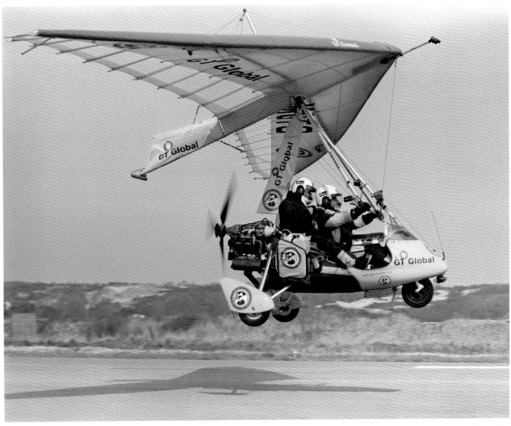

Brian Milton and Keith Reynolds start the second leg of their 'Round the World in 80 Days by Microlight' trip by taking off from Le Touquet Airport in France. They would suffer no end of setbacks, including engine problems, being delayed by officialdom and being buzzed by jet fighters. Reynolds gave up in Alaska, but Milton continued, returning home after 120 days.
24th March, 1998

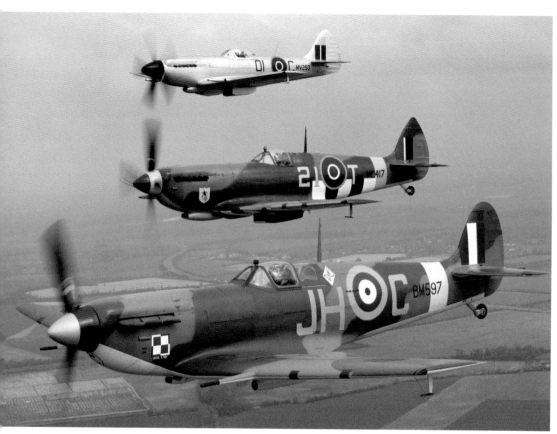

A formation of restored Spitfires over Duxford Airfield, near Cambridge. A Mk 5 is nearest the camera, with a Mk 9 in the centre and a Mk 14 furthest away. They were preparing to appear in an air show celebrating the 60th anniversary of the famous fighter, which first rolled off the production line in mid-1938.

30th April, 1998

Former RAF pilot Flight Lieutenant Geoffrey Boston poses with the propeller of the Handley Page Hastings aircraft that he flew during the Berlin Airlift of 1948, which is displayed at the Imperial War Museum, Duxford, near Cambridge. The airlift kept the inhabitants of the city provided with essential supplies during a Soviet blockade.
15th June, 1998

Airmen of the Third Division of the German Air Force during a wreath laying ceremony to mark the anniversary of the Berlin Airlift, at a British Army compound in the Spandau district of Berlin. Behind is a Douglas C47 Dakota that took part in the operation, during which Allied aircraft made 20,000 flights and delivered 13,000 tons of food daily for almost a year.
26th June, 1998

A kaleidoscope of hot-air balloons, some with the most amazing shapes, jostles into the blue sky of early evening at the Bristol International Balloon Fiesta. It seems that modern balloons can be given just about any shape imaginable.
5th August, 1998

L–R: Per Lindstrand,
Richard Branson and
Steve Fossett in Marrakesh,
preparing for an attempt
to circumnavigate
the world non-stop by
hot-air balloon. They are
standing on the roof of
their balloon's gondola.
17th December, 1998

The Ico Global Balloon lifts slowly into the skies above Marrakesh, carrying Per Lindstrand, Richard Branson and Steve Fossett on their bid to circumnavigate the world. They reached Hawaii in record-breaking time, but could not complete the flight before rivals Bertrand Piccard and Brian Jones in the Breitling Orbiter 3.

17th December, 1998

Flight Lieutenant Julie Gibson (R), the first full-time operational woman pilot in the Royal Air Force, and Carly Childs, a pilot with British Airways, compare notes in front of a replica 1909 Demoiselle at Brooklands Museum, near Weybridge, Surrey. They were there to help launch a new exhibition, *Women in Aviation*.
11th March, 1999

Ann C. Welch, OBE, AFRAeS, seated in the cockpit of a vintage glider at the launch of *Women in Aviation* at the Brooklands Museum, near Weybridge, Surrey. Ms Welch had enjoyed a long and varied flying career, which began in the 1930s: as a private pilot, a glider pilot, a wartime ATA ferry pilot and a postwar sporting pilot. She was also an author of technical aviation books.

11th March, 1999

Breitling Orbiter 3 touched down in the Egyptian desert, about 300 miles southwest of Cairo, after a record-breaking trip that began on 1st March, 1999 in the Alpine village of Château-D'Oex, Switzerland. Briton Brian Jones and Swiss Bertrand Piccard became the first aviators to fly a balloon around the world non-stop. The Rozière balloon combines features of a hot-air balloon and a gas balloon; a helium cell within the hot-air envelope, heated by the sun, allows the balloon to gain altitude.
21st March, 1999

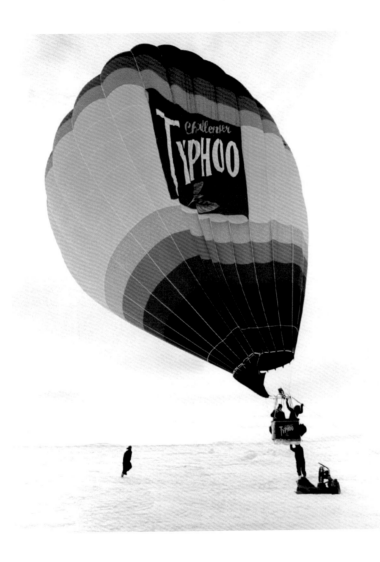

Pilots David Hempleman-Adams and Phil Dunnington, and ground crew Brian Smith, inflate their Typhoo Challenger hot-air balloon at Devon Island in the Arctic. The two flyers, who would touch down safely off the coast of Somerset Island, would be the first to cross the North West Passage in an open-basket balloon.

16th May, 1999

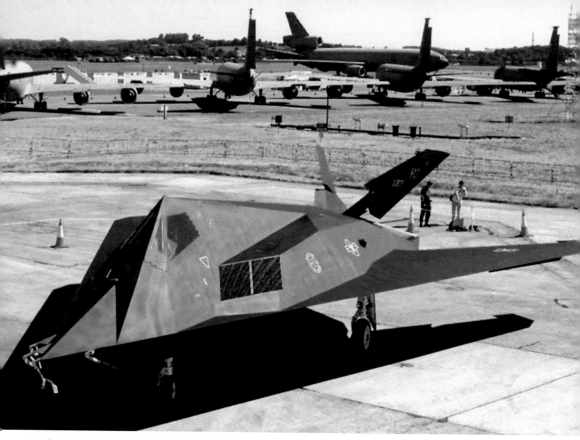

A weird and sinister looking Lockheed F-117A Nighthawk 'stealth' fighter of the US Air Force on display at RAF Fairford during the International Air Tattoo to mark the 50th anniversary of the founding of NATO. The peculiar shape of the machine is said to make it invisible to radar.

23rd July, 1999

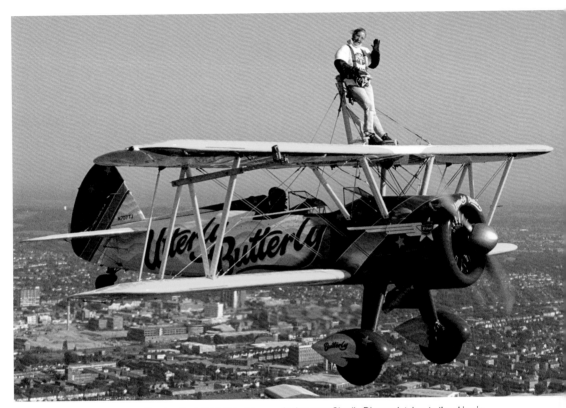

Shepherd's delight. Television gardening guru Charlie Dimmock takes to the skies in unconventional manner on behalf of the Women's Royal Voluntary Service charity, to help mark the third annual Meals on Wheels day. She flew 1,000ft over London clutching a piping-hot shepherd's pie while standing on the wing of a 1940 Boeing Stearman biplane.
6th October, 1999

Former prisoners of the infamous German POW camp Colditz, Jack Best (L) and Bill Goldfinch (R), with a replica of the glider they helped build in the prison, at RAF Odiham in Hampshire. Seated in the cockpit is glider pilot John Lee. The original machine was made in secret in the roof of the prison, but no attempt was made to fly it before the inmates were liberated.

2nd February, 2000

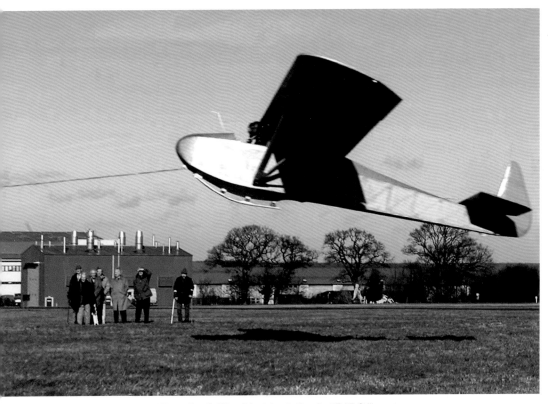

The replica Colditz glider takes to the air at RAF Odiham, Hampshire, watched by former prisoners-of-war who helped build the original. The flight proved that the machine would have flown.

2nd February, 2000

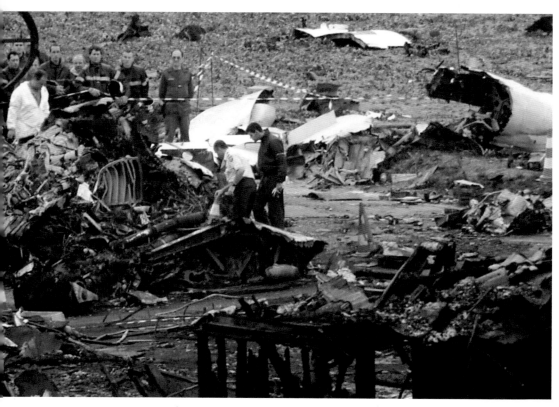

Crash investigators sift through the wreckage of an Air France Concorde that crashed at Gonesse, near Paris, killing all 100 passengers, nine crew and four people on the ground. The cones signify human remains. During the machine's take-off run, debris on the runway had punctured a tyre, which exploded, sending fragments into a fuel tank that ruptured and set the aircraft on fire.

27th July, 2000

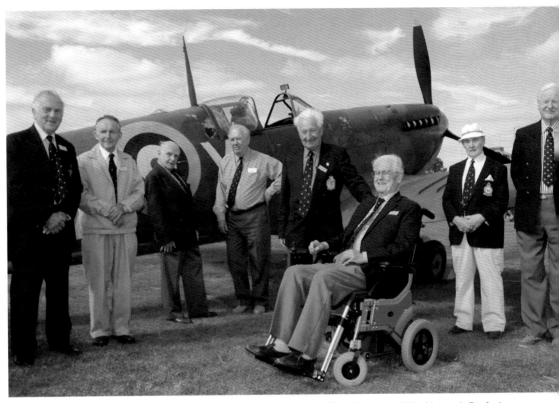

Battle of Britain veterans stand in front of a Spitfire at the Imperial War Museum's Duxford Airfield, near Cambridge. The former fighter pilots were there to commemorate the 60th anniversary of the battle. L–R: Flight Lieutenant Tony Pickering, Warrant Officer James Walker, Pilot Officer Lesley Smith, Flight Lieutenant Robert Foster, Flight Lieutenant Ken Wilkinson, Air Chief Marshal Christopher Foxley-Norris, Flight Lieutenant Jocelyn Millard and Wing Commander Thomas Neil.
10th September, 2000

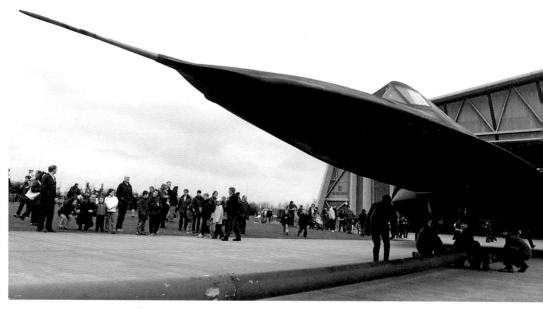

Crowds turn up to watch the Lockheed SR-71 Blackbird
rolled out of its hangar at the Imperial War Museum, Duxford.
The top-secret American spy plane was the latest addition to
the collection of historic aircraft at the Cambridge museum.
Capable of flight at three times the speed of sound, in
1976 the Blackbird set a world altitude record for sustained
horizontal flight at 85,069ft.
11th April, 2001

Carolyn Grace, the only woman Spitfire pilot in the world, prepares for another flight in her two-seat Spitfire. The machine, a veteran of the Second World War, was converted to a two-seat advanced trainer for the Irish Air Force in 1950. It was acquired by Carolyn's late husband, Nick, in 1979 and restored by him. After his death in a car crash, Carolyn took on the role of maintaining and displaying the aircraft.

3rd May, 2001

Major General Donald J. Strait, a former Second World
War pilot with the US Army Air Force's 356th Fighter Group
stands with a P-51D Mustang fighter during the Flying
Legends Air Show at Duxford Airfield, near Cambridge. Strait
was credited with 13.5 enemy aircraft destroyed.
14th July, 2002

The amphibious assault ship HMS *Ocean* launches WS-61
Sea King helicopters during an amphibious operation that
was part of Exercise Saif Sareea II off Oman. The ship can
carry up to 12 of the large helicopters as well as six smaller
Lynx machines.
15th January, 2003

Miles Hilton-Barber, 54, who had been blind for 20 years, with co-pilot Storm Smith (R), at Cumbernauld Airfield, near Glasgow. Hilton-Barber was preparing for his bid to become the first sightless person to fly across the English Channel in a microlight. He would go on to complete a flight from London to Sydney, Australia.
15th August, 2003

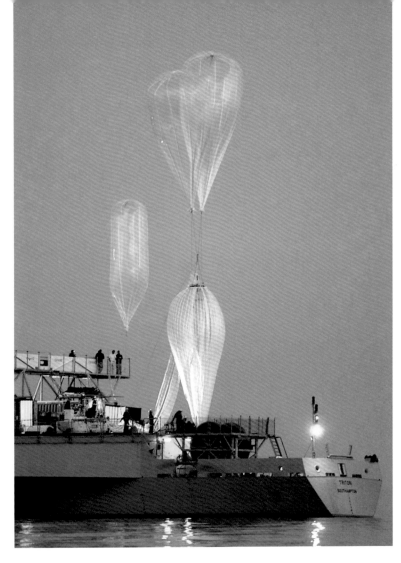

Preparations under way off the coast of Cornwall for pilots Colin Prescott and Andy Elson to make a historic flight to the edge of space in the 1,270ft tall QinetiQ 1 balloon. Their aim was to smash a 40-year-old altitude record and reach a height of more than 25 miles. The balloon was to be launched from the trimaran research vessel *Triton*, but the attempt was abandoned after a tear was discovered in the balloon envelope.

3rd September, 2003

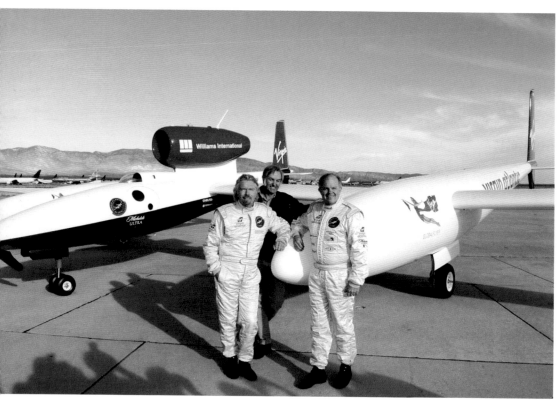

Steve Fossett (R) and Sir Richard Branson (L) with designer Burt Rutan unveil the Virgin Atlantic GlobalFlyer, a specially built composite jet aircraft in which Fossett would go on to fly solo non-stop around the world.

8th January, 2004

Space tourism could be the next giant leap for mankind under a plan unveiled by Virgin boss Sir Richard Branson. He was celebrating the announcement that Virgin Group had entered an agreement to license the technology to develop the world's first privately funded space travel company, Virgin Galactic, in London.

27th September, 2004

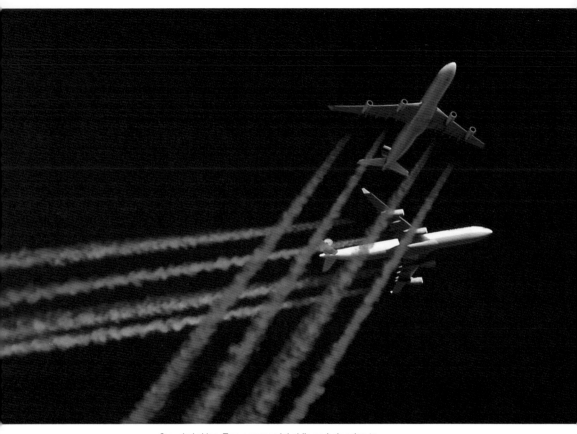

Crowded skies. Two commercial airliners belonging to
Lufthansa (bottom) and Air France appear to pass at close
range in the skies over southwest London. Despite efficient
air traffic control, very occasionally human error leads to
near misses in the air.
9th November, 2006

British Aerospace Hawk
jet trainers of the Royal
Air Force's Red Arrows
aerobatic display team
delight the crowds with
a thrilling display over
East Fortune in Scotland,
during the National
Museum of Flight's
tenth annual air show.
28th July, 2007

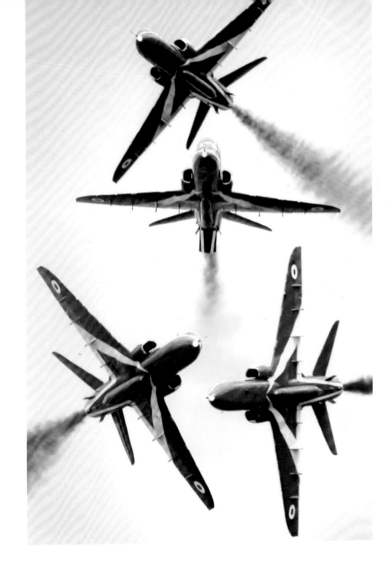

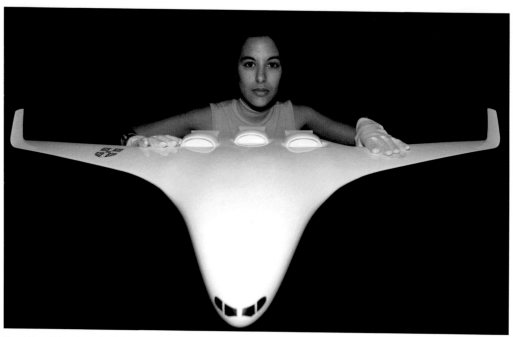

Dominique Driver from the Science Museum, London stands beside a futuristic blended-wing body aircraft from Cambridge University on display at the museum's 'Does Flying Cost the Earth?' exhibition. The concept has been developed as part of the Silent Aircraft Initiative. Designed to reduce fuel burn, the plane is one flying wing. Researchers predict that planes like this could cut carbon emissions by 25% and might become a reality by 2030.
15th May, 2008

Just hanging around. Paragliders take part in The Borders Round of the British Paragliding Cup, near Symington, Lanarkshire. Developed from parachutes, the gliders form wing shapes when deployed and are probably the simplest form of flying imaginable.
12th July, 2008

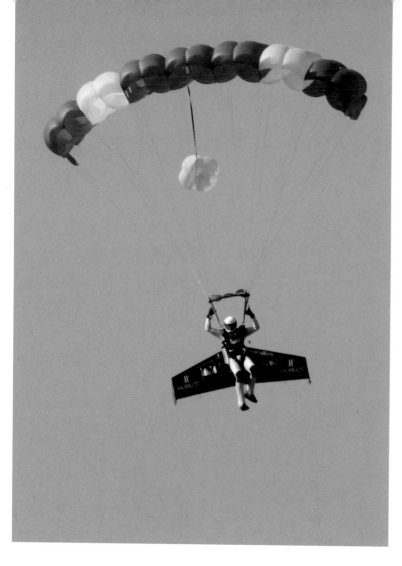

Rocket power. Swiss adventurer Yves Rossy, 49, also known as 'Fusionman', parachutes to land after successfully crossing the English Channel from Calais to Dover using a single jet-powered wing. Rossy jumped from a plane more than 2,500m (8,200ft) above France and soared at more than 100mph over one of the world's busiest shipping lanes powered by four jets on his home-made wing.
26th September, 2008

Pedal power. Two days after Rossy's record-breaking cross channel flight, Frenchman Stéphane Rousson, 39, failed in his attempt to fly more sedately from Hythe, Kent to Calais by pedal-powered airship. After months of waiting for the ideal weather conditions, the 16-metre helium-filled blimp *Mlle Louise* was hampered by shifting winds. The airship was deflated and Rousson ferried to shore aboard a support boat.
28th September, 2008

The largest passenger plane in the world, the Airbus A380, flies over the crowds at the Northern Ireland International Airshow at Portrush. The aircraft is a double-deck, wide-body, four-engine airliner manufacturered by the European corporation Airbus, a subsidiary of the Eurpopean Aeronautic Defence and Space Company (EADS). The 'Superjumbo' provides seating for 525 people in a typical three-class configuration or up to 853 people in all-economy class configurations.

5th September, 2009

British Airways planes parked in the engineering area near Hatton Cross, part of the Heathrow Airport complex, as BA cabin staff continue their strike action. Relations have been turbulent between BA and Unite, the trade union regarding proposed changes to working conditions for cabin crew in respone to the global financial crisis.

28th March, 2010

No-fly zone. A deserted Termnal 5 at Heathrow Airport, as
travellers endured more misery Iceland's 1,676m (5,500ft)
Eyjafjallajökull volcano erupted and sent a plume of dust that
stretched from the British Isles east beyond the Baltic region,
and forced the cancellation of all flights in and out of the UK
and northern Europe.
17th April, 2010

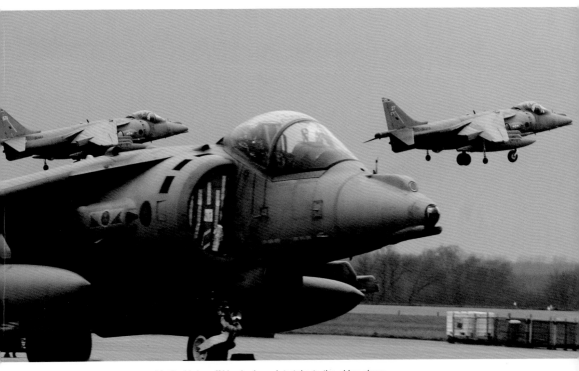

Vertical take-off Harrier jump jets take to the skies above
RAF Cottesmore in Oakham, as they carry out flypasts
on what was billed as their 'final flight' before the axe of
Government spending cuts falls on them.
15th December, 2010

Fifty-one hot-air balloons ascended gracefully from Lydden Hill race circuit in Kent and passed over the port of Dover for the estimated four-hour flight across the English Channel to France. The flight marked the first time a Guinness World Records bid had been staged for the largest group of balloons to make the Channel crossing, which attracted competitiors from across Europe.

7th April, 2011

Apache attack helicopters at AAC Wattisham Flying Station near Ipswich in Suffolk, during a showcase at the base. The event was organised to mark the helicopters' 100,000th flying hour, and included an air demonstration and a review of the latest deployment troops from the Army Air Corps to Afghanistan.
25th May, 2011

The Publishers gratefully acknowledge Press Association Images, from whose extensive archives the photographs in this book have been selected. Personal copies of the photographs in this book, and many others, may be ordered online at www.prints.paphotos.com

07/13

AMMONITE
PRESS

PRESS
ASSOCIATION
Images